SPACE ART

HOW TO DRAW AND PAINT PLANETS, MOONS, AND LANDSCAPES OF ALIEN WORLDS

M. CARROLL
91

WATSON-GUPTILL PUBLICATIONS/NEW YORK

SPACE ART

HOW TO DRAW AND PAINT PLANETS, MOONS, AND LANDSCAPES OF ALIEN WORLDS

MICHAEL CARROLL

First published in 2007 by Watson-Guptill Publications,
Nielsen Business Media, a division of The Nielsen Company
770 Broadway, New York, NY 10003
www.watsonguptill.com

Library of Congress Cataloging-in-Publication Data

Carroll, Michael W., 1955–
 Space art : how to draw and paint planets, moons, and landscapes of alien worlds / Michael Carroll.
 p. cm.
 Includes index.
 ISBN-13: 978-0-8230-4876-2 (alk. paper)
 ISBN-10: 0-8230-4876-4
 1. Outer space–In art. 2. Planets in art. 3. Fantasy in art. 4. Art–Technique. I. Title.
 N8234.O8C37 2007
 743'.8523–dc22

 2006033585

Executive Editor: Candace Raney
Editor: Michelle Bredeson
Designer: Kapo Ng@A-Men Project
Senior Production Manager: Alyn Evans

Printed in China
1 2 3 4 5 6 7 8 9 / 15 14 13 12 11 10 09 08 07

ACKNOWLEDGMENTS

My thanks to the art students of the Valorie Snyder Studio and the Credo Academy, for your hours of patience with my teaching. Without you, I couldn't have done this book! Chris Zotter helped me get started on my first painting chapters. She's a fine lowbrow. Rosemary Clark helped me smooth out the icy wrinkles on the Triton painting. Thanks to Grant Johnson for his beautiful Earth photography. Thanks, also, to Carolyn Porco, Guy Webster, and Mike Malin for making available close views of cosmic wonders. A special thanks goes out to Cindy Haase, Julie Porter, and Valorie Snyder, all extraordinary artists and good-humored friends! To my guest lecturers, you've given me years of encouragement and brutal critiques, all an artist could want. And to my wife—creative, sharp, and extraordinary in every way—you are my favorite "heavenly body"!

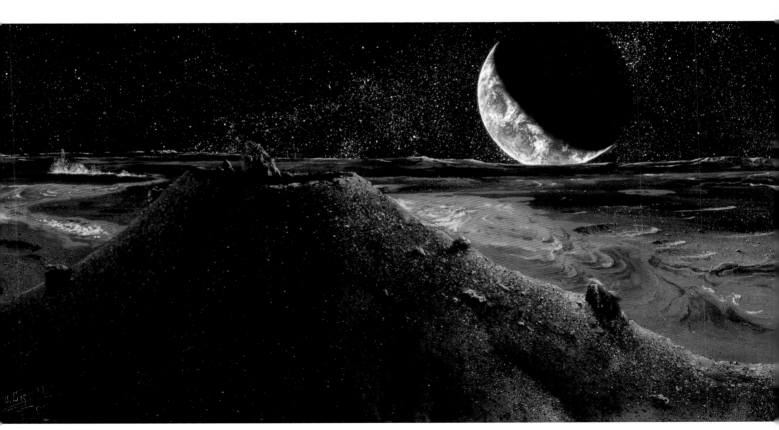

MOONGLOW **BY MICHAEL CARROLL**

CONT

INTRODUCTION
 SPACE ART: WHAT IS IT AND WHERE DID IT COME FROM? **8**

PART ONE
 DRAWING AND PAINTING ALIEN WORLDS **12**

 Drawing Alien Worlds **14**
 Painting Alien Worlds **28**

PART TWO
 THE EARTH-LIKE WORLDS **36**

 The Earth from the Moon **38**
 A Landscape on Mercury **44**
 A Venusian Volcano **48**
 Mars from Deimos **56**
 Ancient Mars **62**
 Modern Mars **70**

PART THREE
THE GAS GIANTS 76

 A View from Jupiter's Moon Io 78
 A Jupiter Cloudscape 84
 Saturn Seen from Iapetus 91
 A View of Neptune from Triton 100

PART FOUR
WORLDS BEYOND NEPTUNE 108

 Pluto and Its Moon Charon 110
 Melting World with Two Suns 120
 The Rocky Show 128
 Water World 135

RESOURCES FOR ARTISTS
IN THE AGE OF SPACE EXPLORATION 143

INDEX 144

INTRODUCTION

SPACE ART: WHAT IS IT AND WHERE DID IT COME FROM?

It's a big universe out there, and it takes a big brush to paint it, right? Wrong! Using simple, step-by-step drawing and painting techniques, we'll render some of the most spectacular vistas in the cosmos. With pencil and paintbrush in hand, we'll visit the sparkling ice mountains of Saturn's moons, the precipitous canyons of Mars, and the thundering volcanoes of a Jupiter moon. But before we leap into space with both feet, let's take a brief look at where space art came from.

Artists have been painting new frontiers for a long time. In the early years of the United States, Congress sent expeditions to explore the "unknown lands" to the west (these lands were unknown to Europeans, not to Native Americans, who had been living there for thousands of years). Many of these expeditions brought artists along. It was, in large part, the paintings of Thomas Moran and Albert Bierstadt that convinced Congress to establish the first two national parks at Yellowstone and Yosemite.

These days, we send explorers into a higher frontier. Some of these pioneers wear spacesuits and come home to tell their tales. Others have metal skin and solar panels and beam their findings home through radio antennas. Space artists use the reports of these pioneers to inform their paintings, showing the world what it's really like to be in some of the most dangerous and beautiful places in the cosmos.

But long before the dawn of space exploration, artists were turning their paintbrushes and their imaginations toward worlds beyond Earth. Early people saw the planets as starlike objects. Along came the Italian astronomer, physicist, and philosopher Galileo Galilei in the late 1500s and early 1600s, who, through his small telescopes, first saw the planets as real worlds. Galileo was the first to see that the Moon's face was pockmarked by craters, bowl-shaped depressions that are caused—we now know—by impacts of meteors, asteroids, and comets. One planet Galileo studied was Jupiter. Through the lens, he discovered that the starlike object was actually a globe, and he became intrigued by the four tiny "stars" that seemed to travel back and forth around the planet. It was the first time a human being had seen moons orbiting a planet. He sketched what he saw, becoming, in effect, the first space artist. Ever since then, people have been drawing other worlds.

As telescopes got better, so did space art. People realized that the planets and their moons were places with deserts, peaks, and plains. Jupiter was revealed to be a striped world. Mars played host to a web of dark lines and blotches, along with snowy polar caps much like Earth's. Could these caps be made of frozen water? As the caps melted in the local summer, a wave of darkening spread through the dark areas, and observers came to the logical conclusion that the dark areas were vegetation—Martian jungles watered by melting polar snows. (These dark areas were later discovered to be volcanic dust blown by seasonal winds.)

Many mapmakers recorded straight lines on Mars, and the Italian astronomer Giovanni Schiaparelli called these *canali*, Italian for "channels," in the late 1800s. He did not intend to imply an intelligence behind those lines, but the idea was planted, especially when many English-speaking scholars translated the word as "canals." The canals of Mars took on a life of their own. From his observatory in Flagstaff, Arizona, in the early 1900s, Percival Lowell crafted detailed maps of canal networks, oases, lakes, and hubs of civilization.

One of the first great space artists was Lucien Rudaux. Rudaux was an accomplished painter as well as the director of the Meudon Observatory outside of Paris, France. At the beginning of the twentieth century, Rudaux painted remarkably realistic scenes of the Mars and other planets, based on his observations. The true father of modern space art, however, was Chesley Bonestell, whose career spanned most of the twentieth century. Bonestell worked with rocket scientist Werner von Braun to depict realistic scenes

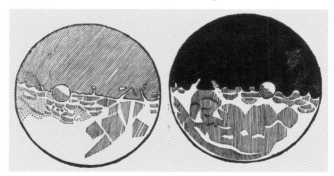

Two views of the Moon by Galileo. Galileo proved that the Moon is not a perfect orb but rather is covered by pockmarks, mountains, and dark regions. (Courtesy the Science & Society Picture Library)

Opposite: **MARS VOLCANO BY MICHAEL CARROLL**

of people on other planets. Bonestell inspired an entire generation of scientists and engineers who made space exploration happen.

Science fiction writers also incorporated scientific revelations into their work, which, in turn, inspired artists and piqued their curiosity about other worlds, especially Mars. In 1898, H. G. Wells wrote a socially paranoid treatise called *War of the Worlds* in which it was assumed that his alien invaders came from nearby Mars. Edgar Rice Burroughs gave us *A Princess of Mars* with her attendant six-legged beasts in 1917 (originally serialized as *Under the Moons of Mars* in 1912), and, in 1950, Ray Bradbury penned the *The Martian Chronicles*. Artists had a field day. What did a Martian canal look like? What did a Martian look like? And Martian flying machines and cities and armies? In early drawings and paintings of Mars, the landscapes looked very Earth-like.

In 1957, the Soviet Union orbited the first artificial satellite, *Sputnik 1*. The beeping sphere caused a sensation. In the midst of the Cold War, the United States was thrust into a "space race" with the Soviets. Both countries struggled to write the most "firsts" into the history books. The Soviets racked them up: the first satellite, the first animal in space, the first astronaut. Both countries sent robotic craft toward the Moon and planets, but it was a tough go. The Soviet *Lunik 2* took the first images of the far side of the Moon. U.S. craft soon followed. But the planets were a different ball game altogether. The closest, Venus, is one hundred times as far from Earth as the Moon. The Soviets and Americans tried to get craft to this cosmic neighbor. The American craft *Mariner 2* was the first, flying by the planet to take its temperature and other measurements. Many other craft, including landers and balloons, followed.

An armada of spacecraft winged its way in the opposite direction, toward the red planet. The first images of Mars were fuzzy, black-and-white views, but they showed something unexpected: craters. Later, orbiters and landers were to reveal a world unlike the Moon, and hauntingly like Earth in some locations. Some regions of Mars bear a striking resemblance to the desert southwest of the United States, the tundra of Iceland or Siberia, or the arctic deserts of Antarctica. Landers and rovers have shown us beautiful vistas of chocolate-brown rocks, sand dunes, dust devils, tan-colored skies, and blue sunsets. Mars is, indeed, an alien world.

Early artists had only telescopes and the imagination to inform their astronomical drawing and painting. Now, thanks to astronauts and robot spacecraft, we've begun to study other worlds in detail. We've found landscapes both mysterious and inspiring. And we've discovered echoes of Earth out there. Mars is not the only place to have terrain similar to our own. Venus has vast deserts, great volcanoes, and steep canyons. Mountains of many kinds are found on all of the Earth-like—or terrestrial—worlds, but they often rise above more bizarre plains of frozen water and nitrogen ices. Mountains and canyons are also found on ice worlds like Pluto and Titan, Saturn's largest moon.

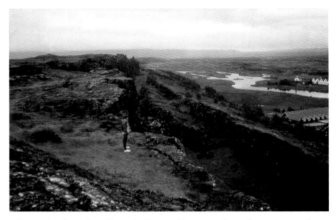

The Icelandic rift valley of Thingvellir provides a form for a rift on Triton, Neptune's largest moon, which is depicted in the painting below. (Photo by author)

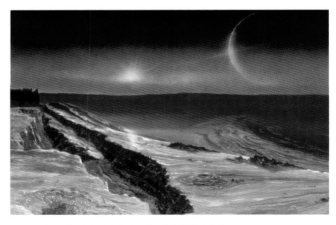

TRITON **BY MICHAEL CARROLL**

Today, artists continue to work with scientists, showing us vistas that cannot be seen by humans with our current technology. Through the paintbrush of the space artist, humans can explore the wonders of the cosmos.

Space artists also travel to the ends of the earth to study any geology that might find its analogue in the cosmos. They are guided by science, as well as by imagination. As we step through the solar system in the following pages, we'll see some of these comparisons and use them to help us paint the worlds around us. After a brief overview of drawing and painting techniques that are specific to space art, we'll tackle the solar system and beyond in step-by-step painting demonstrations. In this book, you'll learn a lot of new techniques through the first few paintings, but as you master these techniques, each painting will become easier. Trust me! Except for our introductory painting of Earth as seen from the Moon, the paintings are arranged by their subject's distance from the Sun, so the first is Mercury, while the last few are imagined worlds beyond Pluto.

The paintings fall into three levels of difficulty: beginner, intermediate, and advanced. With some exceptions, the paintings progress from easier to more difficult, but skills you learn in earlier paintings will seem like second nature when called upon for use in later paintings.

In this book, you'll explore a little of the science behind each painting and, with paintbrushes as your traveling companions, take a grand tour of the solar system and what lies beyond.

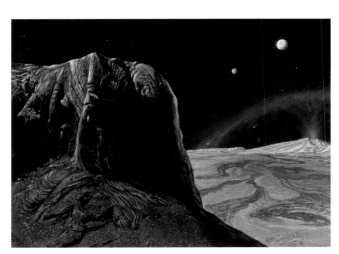

IO **BY MICHAEL CARROLL**

Lava forms in Hawaii supply inspiration for the painting of Jupiter's volcanic moon Io at right. (Photo by author)

PART ONE

DRAWING AND PAINTING ALIEN WORLDS

Whether you're clinging to the broiling cliffs of Mercury, sliding around the frozen wastelands of Pluto, or standing on a mountaintop in Colorado, the same laws of nature—and art—apply. Space art is simply landscape art in a place other than Earth.

In this book, we'll be concentrating on painting techniques, but drawing some foundational elements first will prepare you for the adventure. We'll kick things off with a few notes about drawing landscape forms, drawing three-dimensional objects, shading, and texture. After we break in our pencils, we'll have a look at general painting guidelines. In this book, we'll be painting with acrylics, a flexible medium perfect for space art. Grab your drawing and painting tools and come on an adventure to planets, moons, and asteroids across the cosmos. Enjoy the ride!

DRAWING ALIEN WORLDS

To develop good painting technique, one must cultivate good drawing technique. With a pencil or pen, we can define shape and shadow, texture and form. Once we get the fundamentals down, we'll introduce color and then move on to paint.

When laying out a drawing, first outline the general forms of shadow and light. It really helps to go outside and look at how sunlight affects shadows on rocks and stones. Visit a rock quarry or take a trip to a park and just sit in front of a rock for a while. (If anyone asks what you're doing, just tell them you're a space artist. They'll give you lots of room!) Taking photos and making sketches in the field are valuable practices for any landscape artist, and they'll help you avoid cookie-cutter rocks, cliffs, and mountains.

BASIC MATERIALS

Some helpful materials for drawing include graphite pencils, colored pencils or pastels, charcoal, and ink. Ink and charcoal bring a greater variety of line and provide more contrast than pencil, but pencils, which come in different degrees of hardness, can also give you the variety you need for different landscapes. A 6H pencil is hard, an HB pencil is medium strength, and an 8B is very soft. The harder the pencil, the lighter the line. Which one you use depends on the type of line or shading you want to use in your drawing. We'll be using pencil and colored pencil for the sample drawings in this chapter.

A pink pearl eraser comes in handy for lifting color or removing unwanted areas of your drawing, as does Elmer's Orange Tack Putty. For colored pencil, what works even better is an electric eraser (a wonderful tool, often used by mapmakers at the U.S. Geological Survey to remove or lighten graphite on planetary maps), or Scotch tape. Just put the tape down gently, draw over the part that you want to remove, then lift the tape. A kneaded eraser is the best tool for erasing charcoal. Circle and ellipse templates are handy for getting the shadows on a planet or moon just right.

Use a fairly heavy drawing paper. You can also experiment with sketchbooks from an art store. Paper with a rough surface, "or tooth," is usually good for texture and blending. Once you finish a few drawings on white paper, try doing some sketches on darker or colored paper for different effects.

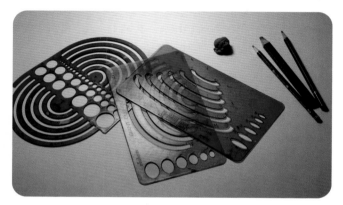

A few basic drawing tools: circle and ellipse templates, kneaded eraser, and graphite pencils.

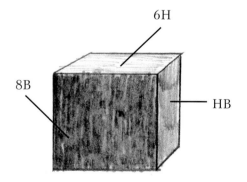

You can define shadows and shapes using the pencil strokes of different types of pencils.

DRAWING SPHERES

Well-known space artist Don Dixon says that most space art consists of "rocks and balls." Drawing a ball, or sphere, is a great way to understand how to shade objects and how to render planets and moons. The large bodies of our solar system are very round and regular. The reason for this is that the larger an object is, the more gravity it has. The more gravity it has, the more it tries to collapse onto itself, making the most compact shape: the sphere. Smaller bodies like asteroids and tiny moons are not round, but we'll tackle them when we get to drawing craters.

To draw a sphere, start with a circle. Imagine that you are looking at a globe. The places where the globe attaches to the stand are its poles. Draw a line through the very top and bottom—the poles—of the circle. The line through those poles is called the axis, which is a good Scrabble word.

Notice in the drawing below that the sphere can be split into slices, much like the sections of an orange. Each of these slices ends in a point at the poles of the sphere. (On an Earth globe, these lines are the same as the lines of longitude.) Use each individual slice as a guide to show you where the shadows will fall on your sphere. If the light is directly in front of the sphere, the sphere will be "full," with no shadow. As the light source moves around to the side, a shadow appears on the opposite edge and gets thicker and thicker as the light source moves around the sphere, but it always ends at the poles. Finally, when the light is behind the globe, the entire sphere is dark. Make sense? You can test this principle with a small lamp and a soccer ball in a darkened room. Experiment with how the light falls on the ball. See how the shadows always line up perfectly with the poles of the ball? It works the same way whether your sphere is a soccer ball or a planet.

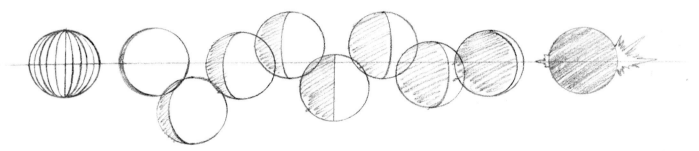

You can divide a sphere into slices that follow the contour of the sphere from top to bottom, or pole to pole (*far left*). As a light source moves from directly in front of the sphere (*second from left*) to directly behind it (*far right*), the slices fall into shadow one by one, until the entire sphere is in shadow.

What's important to remember is that everything in your picture is going to have the same shading, or phase. The light falls the same way on the moon in the sky as it does on the rocks in your foreground. Even the mountains have roughly the same shadowed areas.

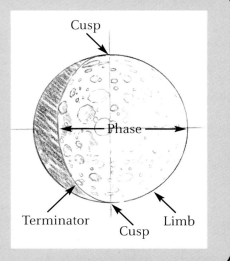
MOUNTAINS

We have found mountains on nearly every large planet and moon in the solar system. Some mountains are built by volcanoes, while others rise up as slabs of rock, thrust above the surrounding plains by internal forces.

Most mountain chains on Earth are formed by plate tectonics. Our planet is built like a big jigsaw puzzle, with the puzzle pieces floating on hot rock the consistency of rubber. These plates drift around: You can see where Africa used to fit against South America. Sometimes plates subduct, or slide under each other. In other places, plates crash into each other, wrinkling their edges into mountains. The Himalayas are still being formed by one plate—which carries India—crashing into the Asian plate.

On other planets, the processes that build mountains are not exactly like our plate tectonics. Venus has columns of rising rock that form strange, circular features called *coronae*. Mars has mountains built from the impacts of asteroids and the shifting of ground caused by the eruption of volcanoes. The moon Io has massive mountains created by the gravity of nearby Jupiter, which disrupts its surface. So, while there are mountains on other planets and moons, their origins are often quite different from the mountains we know.

To draw a mountain, start by thinking of it as a pyramid. Like a pyramid, a mountain has a shadowed side and a lit side. But mountains don't really look like pyramids. In fact, most things in nature have a beautiful randomness.

In a painting or color drawing, the more distant an object is, the more of the sky color it should take on. "Purple mountain majesties"doesn't refer to real, purple mountains. Mountains are red, green, and brown, but since we are looking through a lot of blue air between us and them, the blue combines with the mountain color to shift it; brown becomes purple, for example (see "A Venusian Volcano" on page 48 for an example of this technique). On planets where there is no air, this does not actually happen, but as artists we may choose to depict things in this way for clarity.

Closer mountains will appear more rugged than ones farther away. Use shadow to define how rough a mountain is by making the shadow mix with the highlights, alternating between shadow and light at the edges.

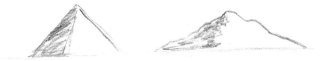

Unlike pyramids, mountains are bumpy. But even the bumpiest of mountains have a shadow that will roughly follow the same shadow pattern as the moon in the sky. In other words, as the light source moves from left to right across a mountain, the shadow will spread across the mountain in increasing sections until the mountain is completely in shadow (when the light source is behind it).

Here we see "blobby" mountains with more distant mountains behind. The farther away an object is, the fainter and less distinct it will be in our drawing. This is called atmospheric perspective.

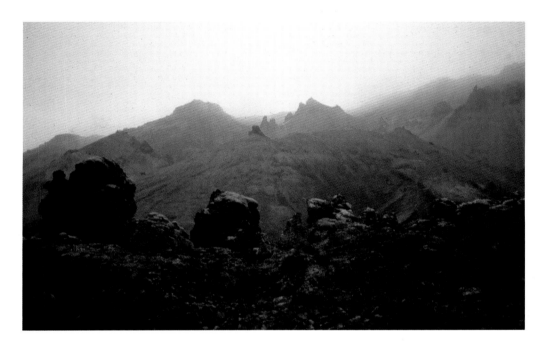

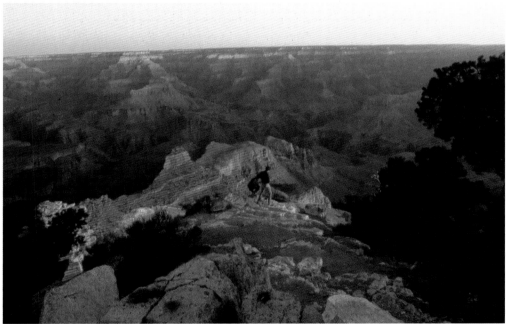

In the top photo of mountains in Landmannalaugar, Iceland, you can see that the mountains in the distance become less distinct. Details on the far wall of the Grand Canyon, shown in the bottom photo, are muted compared to those close up. (Photos by author)

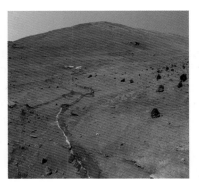

Mountains come in many forms and sizes on the moons and planets of the solar system. From left to right: Himalayan Mountains, coronae on Venus, mountains of the Columbia Hills on Mars, and rugged ice mountains of Jupiter's moon Europa. (Photo credits from left to right: satellite image courtesy of GeoEye; from the *Magellan* mission, NASA/JPL; *Spirit* rover photo, NASA/JPL; from the *Galileo* mission, NASA/JPL)

An artist can define the front edge of a mountain by placing a shadow behind it.

AVOIDING TIN SOLDIERS

At this point, I should mention one of the most important concepts in landscape art: the randomness of nature. My students will be cringing right now, because I can't say it enough. Nature is random (there, I said it again). Shapes rarely occur in nature without variation, but our brains are designed to recognize shapes and similarities in objects. We must continually fight against this tendency of ours to assume that if one rock is a certain shape, all rocks are, and draw them all the same way. I call this phenomenon "drawing tin soldiers." Every time we draw a small dent or lump in a mountain or rock or asteroid, the next one should be different—not another tin soldier. Each time we put down a pencil line or brushstroke, we must tell ourselves to make it different from the last. Otherwise, we end up with rows of identical rocks and cookie-cutter mountains.

MESAS

Some landforms are less like pyramids and more like . . . top hats. Mesas form when a plain is fractured and eroded over time. A mesa is a rectangular, flat-topped rock formation surrounded by a base of gravel and broken rock. This base of rubble is called a talus slope, which is a great term to impress all your friends with the next time you're on a hike. Mesas are found on Mars and probably also exist in some form on Venus, which is very Earth-like, geologically speaking. You'll learn more about how to paint mesas when we take a look at "Modern Mars" on page 70.

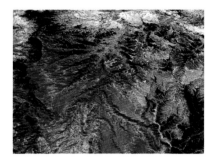

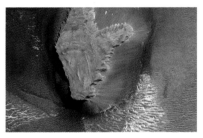

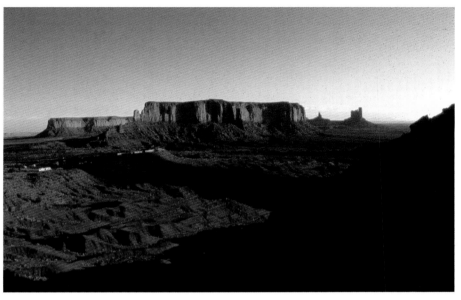

Mesas are found on Mars, as we see in this false-color photo of the Tarantula Mesa (*top*) and a natural-light shot of Mars (*bottom*). (Top: © Grant Johnson; bottom: courtesy NASA/JPL/Malin Space Science Systems)

The photo of a mesa was taken in Monument Valley, on the Utah/Arizona border. The long rectangle of cap rock, surrounded by a pile of debris (the talus slope), is clearly visible. If you look at the photograph carefully, you can see lots of color bouncing around. The shadows are not black, but a darker shade of the reddish stone. Within these shadows we see reflections of the sky as shades of blue or purple here and there. We will use this photo as our reference for the step-by-step colored pencil drawing of a mesa that follows. (Photo by author)

Here we have the general form of a mesa, but by looking at nature (or at least a photograph of nature) we can do better.

Step 01 First, make a detailed sketch with a graphite pencil, picking and choosing just the details from the photo that you want. Outline the general forms of shadow and light.

Step 02 Fill in the shadows, leaving plenty of paper showing through for your future colors. You'll want to make use of the subtle colors of nature, so start with a deep blue pencil. (Note that various brands of colored pencils label their colors differently, but ultramarine or Copenhagen are good typical deep blues.) The lines should follow the contour of the land, so that the color drapes down the hills and flat across the face of the cliffs.

Step 03 Next, fill in richer color, using a deep, reddish-brown like Tuscan red, terra-cotta, or burnt sienna. Move to mid-tones, such as burnt ochre.

Step 04 Finish with a light yellow-brown like sand or yellow ochre. Finally, work the colors together using the light yellow-brown pencil for light areas and the dark blue or reddish-brown for shadows. This will soften your lines a bit, providing a more continuous color range. Blending colors together in this way is called burnishing, and it can be tricky. Colored pencil artist Julie Porter has another suggestion for blending: "Some colored-pencil manufacturers offer a colorless blender that has the same effect without adding the quirks of a pigment pencil and is very, very fun to use." The key is to experiment on another piece of the same type of paper and see what works for your drawing.

CRATERS

Craters are found in every corner of the solar system. During the formation of the planets, there was a lot of debris floating around. Mountain-sized asteroids, rocks the size of small moons, and comets—floating icebergs of frozen dust and gas—all contributed to the makeup of the planets we see today. At the end of this period, the planets and moons had enough gravity to pull in a lot of this primordial stuff, and as the comets and asteroids and meteors made impact, they left craters. In general, craters are round bowl-shaped scars, but we find a wide range—some with gigantic depressions textures inside and halos of debris outside—of these cosmic blemishes. Craters come in all sizes, from thousands of miles across to microscopic pits. Our drawings and paintings of craters must reflect these variations.

A planet's surface is protected by atmosphere, which burns up all but the largest meteors coming in. The more atmosphere a place has, the fewer craters you'll find. Earth has impact craters, but they are often buried, weathered away by wind and water, or hidden on the ocean floor. If you want to see how many craters Earth used to have, just look next door at the Moon!

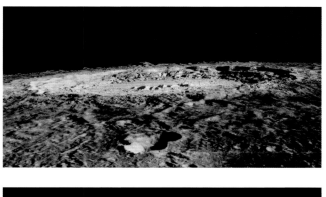

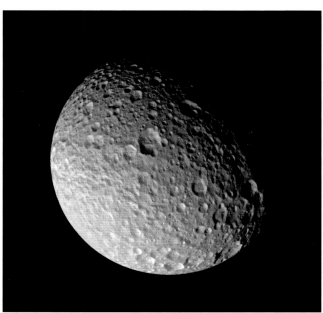

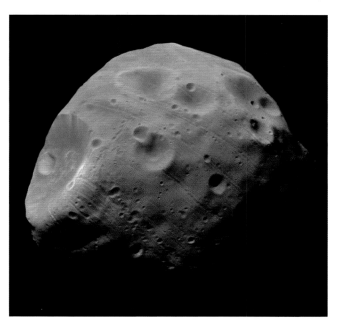

Craters come in many forms. The moon's massive crater Copernicus (*top left*) has many terraced walls. Rounded craters on Mars (*top right*) have soft edges and highlights. Saturn's moon Mimas (*bottom left*) is a great example of round craters following the horizon. Even on an irregular moon like Mars's Phobos (*bottom right*) the craters follow the haphazard limb of the body. (Credits–clockwise from top left: NASA/JPL/*Apollo 17;* NASA/JPL/Malin Space Science Systems; ESA/*Mars Express;* NASA/JPL/*Cassini* mission)

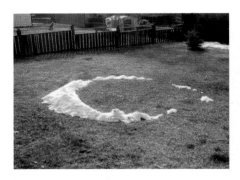 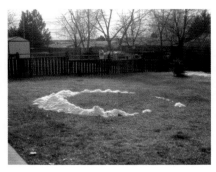

The closer a crater is, the more round it looks. Nevertheless, if you're standing on a landscape looking toward the horizon, any crater will appear oval. Notice the snow crater in my backyard and how it compresses as it moves into the distance toward the horizon. (Photos by author)

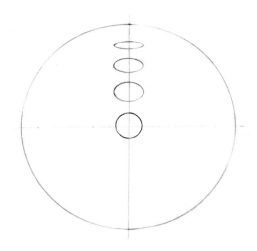

On a perfect world, all craters would be the same size. This would make drawing them much easier, so we'll pretend we have a perfect world to work with and start there. Here, we see a line of craters, each the same size. The crater in the center of our ideal moon is perfectly round. This is because it is pointed directly at us. As we move away from the center toward the limb, each crater becomes compressed in its vertical dimension. The farther away the crater gets, the more elliptical it becomes, until finally, just by the horizon, the crater becomes a simple line.

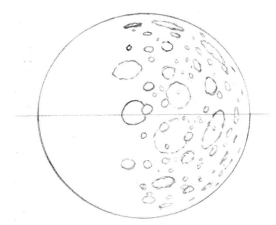

But now we must remind ourselves of my favorite phenomenon: the randomness of nature. Not all craters are created equal. Craters come in different sizes and arrangements. As you randomize your craters, each must be different from the last in size, and you can vary their shapes a bit, too. An important rule of thumb is that for every crater of a given size, you will have six or eight half as large (a few biggies, lots of little ones). Notice too that the longest dimension of any crater is parallel to the nearest edge of the planet.

Now, it's time for shading. The craters nearest the sunlit side will be full of light. Often, we can scarcely see craters near the limb of the sunlit Moon. But as the craters make their way around toward the terminator, they begin to fill with shadow. Some bowls have no rim, so the crater is a simple shadow on one side, fading to a highlight on the other. (A strange quirk of nature is that the lighting on a crater is exactly the opposite of the lighting on a globe.)

PLANETS WITHOUT CRATERS

On some planets, craters are scarce. Very few meteors fall in modern times. Although about three tons of tiny meteors fall to Earth every day, this is a far cry from the continuous pounding the planets took early in their formation. Venus has virtually no craters, because its atmosphere has protected it from most falling cosmic catastrophes. Jupiter's moon Europa has only the rare crater, since its surface has been flowing and fracturing, obliterating most of its cosmic pockmarks.

Not all planets have craters. In fact, some planets have no solid surface at all! The four largest planets are gas giants: Jupiter, Saturn, Uranus, and Neptune. They all have bands of clouds, but their surfaces appear very smooth and fluid. The bands on Jupiter are the most pronounced, so we'll tackle it as our example on the next page.

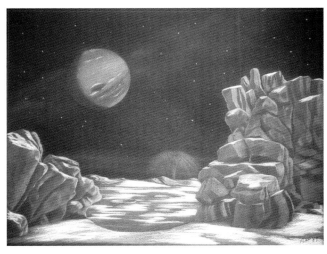

TRITON BY MARILYNN FLYNN

This colored pencil rendering shows the soft gas giant Neptune in the sky of its moon Triton. (© 1989 Marilynn Flynn/Tharsis Artworks)

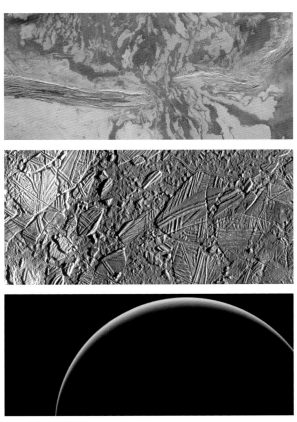

The surfaces of Venus (*top*) and Europa (*middle*) have few craters, and gas giants like Uranus (*bottom*) have none at all. (Images courtesy NASA/JPL)

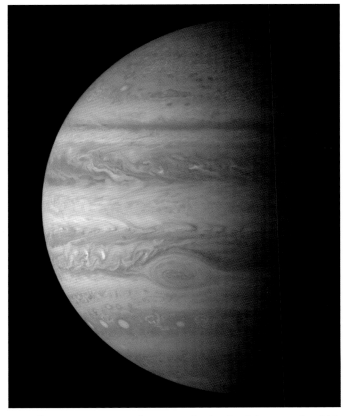

For reference, use a postcard sent to us by the *Cassini* spacecraft, which snapped this shot as it coasted by Jupiter on its way to Saturn. (Image courtesy NASA/JPL)

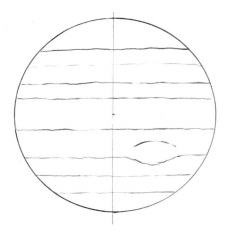

Step 01 Begin by noticing the general pattern of Jupiter. It has dark and light belts and zones of clouds stretching horizontally across its surface. A wide, light-colored belt defines the equator. The darkest belts are above and below it. Toward the poles lie dark brown regions with both light and dark storms.

Sketch in these belts, adding a southward-leaning oval for the Great Red Spot, a cyclone large enough to swallow two and a half Earths.

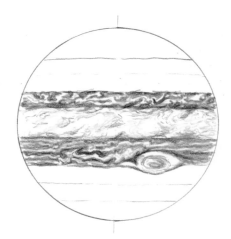

Step 02 Now, work dark reddish-brown colors into the dark belts, being careful to leave swirls for your lighter clouds. Use a little magenta or purple to give it more depth.

Add texture to your equatorial belt, with white areas for highlights and blues and browns for the shadows. Lightly brush a layer of red brick or burnt sienna over the dark belts to soften the cloud forms. Make sure the Great Red Spot is well defined along its edges; it's Jupiter's trademark!

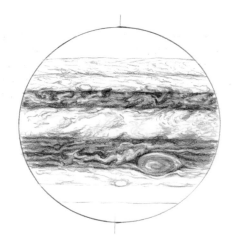

Step 03 Next, render streams of cloud textures above and below in the light bands, blending in some color to the red spot with tans and a light haze of orange.

Add blue tones to the white belts, keeping the warmer colors to a minimum; you want the white belts to stand out. With each successive belt, let the colors play with each other so there is a little mixing at the edges (for example, work some of the red brick or burnt sienna into the edge of the white belts).

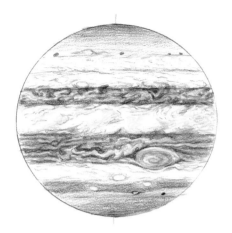

Step 04 Now, work the colors together. Use a white or pale gray pencil or a blending stick to rub colors together in the white belts and a tan one for the brown areas. This softens the clouds. This is the same burnishing technique you used for your mesa. Finally, put a light dusting of tan at top and bottom. Overlay this with deep blue as you approach the poles, with a touch of purple at the darkest north and south. Now, drop in dark oval-shaped storms and dark linear swirls at top and bottom. Most of the little storms are dark, while a few are lighter. Remember to follow the same rules as you do with craters on a surface: The long axis of each storm will follow the limb.

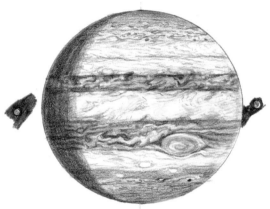

Step 05 Lightly sketch a layer of black over one edge, being sure to follow our orange-slice pattern for the terminator, and remember to stop your shadow at the poles (see "Drawing Spheres" on page 15). Darken the shadow on the night side, but keep it a bit soft right at the terminator. To give a feeling of roundness to your planet, place a layer of pale blue-gray over the sunlit limb of the planet.

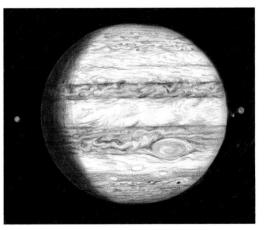

Step 06 Finally, put in one or two of Jupiter's nearby moons, making sure that they have the same phase, or shading, as Jupiter does. Cap it all off with the darkness of space. A black pencil is a good start, but to really get things dark, add a layer of purple and another of dark blue. You can blend various areas together by rubbing gently with a kneaded eraser or blending stick.

HARDBALLS AND SOFTBALLS

Planets come in two types, those with hard surfaces and those with soft (cloudy) surfaces. The hard-surfaced planets, like Earth, Mars, Mercury, and many small moons, including Earth's moon, are brightest on the limb, or edge facing toward the Sun. This only makes sense. We see the same thing when we look at a soccer ball, an orange, or a marble. But the soft-surfaced worlds of the gas giants behave differently. Instead of the limb being the brightest part, these giant worlds tend to get slightly darker at the edge. This is called limb darkening, and it happens because we are looking through a lot of foggy air toward the edge.

Drawing gives us some valuable basics to use when we pick up a paintbrush. We need to carefully plan a painting using the drawing techniques we've looked at here. Okay, it's time to dive into the acrylics and do some cosmic painting!

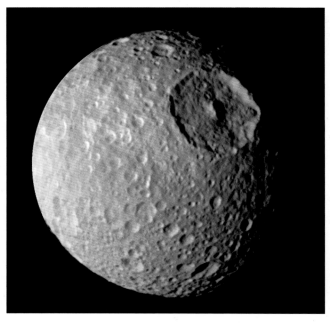

The cratered globe of Saturn's moon Mimas is brightest toward the Sun. This effect is called limb brightening and occurs on all hard-surfaced planets and moons. (Photo courtesy NASA/JPL)

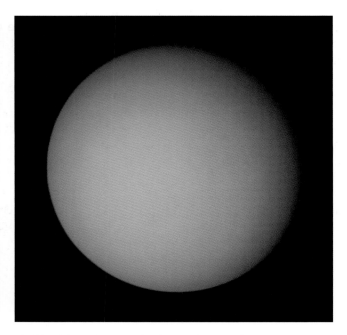

The bland face of Uranus clearly demonstrates the principle of limb darkening. (Photo courtesy NASA/JPL)

GUEST ARTIST
SKETCHING IN THE FIELD BY JOEL HAGEN

Field sketches can be an important part of the process of creating convincing astronomical art. They can also stand alone as drawings or provide a journal of exploration, seeing, and thinking about landforms. I sketch with Prismacolor pencils on black or gray paper so the colors explode from the page. Thirty pencils and a small sketchbook are tidy and easy to carry. I work quickly in 6-inch sketches and let the pencil strokes stand for structures in the landscape.

Knowing that geological processes shape all of the planets and moons of our solar system, it is valuable to explore places on our own planet that are analogous at some level to inaccessible landscapes in the solar system. I especially enjoy sketching in desert regions where the geology is laid bare almost as it is on Mars. For me, sketching is a way of studying rocks and landforms, not merely a way of recording them. With each stroke of the pencil, my eye, my mind, and my hand trace contours, explore textures, discern colors, and register forms. The physical movement of the hand/eye combine with the mental decisions about stroke and color to embed detail in the mind. This experience can be brought forth later in an astronomical drawing or painting as something more than just a memory of shape and color.

Joel Hagen sketching on the plains of Mars (background is from a photo taken by the Mars rover *Spirit*). (Photo courtesy Joel Hagen)

Joel Hagen is an instructor of computer graphics at Modesto Junior College in Modesto, California. In addition to painting and sculpting, Joel has worked as an imaging specialist with NASA Ames Research Center on the *Mars Pathfinder* and *MER* missions. He lives in Oakdale, California.

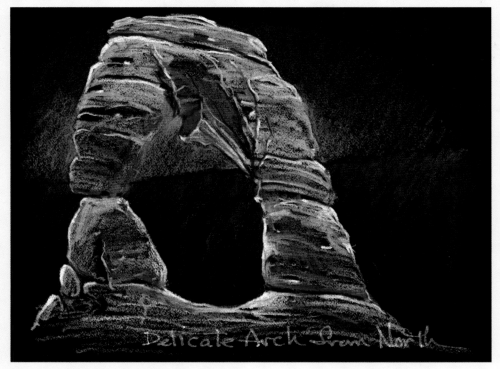

DELICATE ARCH BY JOEL HAGEN
Delicate Arch sketched on site in Arches National Park, Utah. (Courtesy the artist)

PAINTING ALIEN WORLDS

Now that we've covered the basics of drawing alien worlds, we're ready to put paint to canvas. This section will give you an overview of painting materials, how to mix paint, and the basics of color and color theory. Then you'll get to try out what you've learned by painting some Earth and alien skies.

I always do several small sketches before beginning to paint. When I arrive at one I like, it is sometimes helpful to lay tracing paper over the canvas and sketch a real-size version of the preliminary sketch. I refer to this overlay often as my painting evolves.

PAINTS

In this book, we'll be painting with acrylics. Acrylics are very much like oils, but they dry faster and clean up with water. These two features make them quite popular with beginning painting students and professional artists alike. Many space artists like to use acrylics because of their quick drying time, their rich colors and texture, and because they can be used right out of the tube or watered down in a series of subtle washes. In this way, acrylics can be treated with techniques similar to both oils and watercolors. Acrylics come in both jars and tubes, but the paints in tubes are more dense. I recommend using acrylics in the tube. I also advise that you do *not* get student-grade paint, as it tends to be thin and runny.

Below is my short list of the paint colors we'll be using. We'll use a warm and cool version of each of the primaries (see "Basic Color Theory" on page 31), several "flavors" of brown for different effects, and other colors that are perfectly suited for the kinds of landscapes we'll be painting.

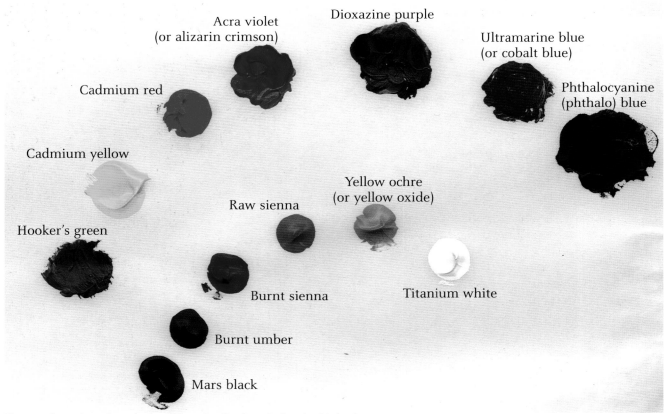

Acra violet
(or alizarin crimson)

Dioxazine purple

Ultramarine blue
(or cobalt blue)

Cadmium red

Phthalocyanine
(phthalo) blue

Cadmium yellow

Yellow ochre
(or yellow oxide)

Raw sienna

Hooker's green

Burnt sienna

Titanium white

Burnt umber

Mars black

Here are the major paint colors we'll be using for the paintings in this book.

PAINTING SURFACES

For your painting surface, you can use heavy illustration board, canvas board, or stretched canvas. Illustration board is good for a smooth, super-realistic painting. Canvas board is easier to transport and store than stretched canvas, and it takes paint in a slightly more uniform way than stretched canvas.

Stretched canvas can be a challenge to paint on, but its rich history and "give" under the paintbrush make for a wonderful painting experience. Because stretched canvas is a material that gives, ebbs, and flows, it is easier to start with a more solid surface. I recommend that beginning students use illustration or canvas board and then try stretched canvas when they are comfortable with the paint.

If you like the feel of canvas, but the texture gets in the way of detail, you can add layers of gesso until it is smooth. Gesso is a white or tinted grainy acrylic medium that coats a painting surface to make it accept the paint more efficiently. Canvas should always be gessoed before painting, even if it is pre-gessoed, as canvas board is. Simply mix the gesso with a little water to thin it out and brush it on with a large flat brush. After the gesso is dry, sand off any brushstrokes to smooth the surface.

BRUSHES AND OTHER TOOLS

I recommend an assortment of brushes, including a soft, round detail brush with a good point (size 0 or 1), a soft, round medium-sized brush (about a size 14), a 1-inch flat bristle brush for mixing color, and a wide (at least 2-inch) flat brush for painting large areas. Artificial brushes (white bristles) are fine, but red sable brushes, though a bit more expensive, can't be beat for quality. A good stiff toothbrush comes in handy for painting many textures in nature. Sponges, both natural and artificial, are also useful, as you'll see when we paint clouds and rocks. I recommend a disposable palette for mixing paint. It makes cleanup easy and is simple to use if you want to paint *en plein air* (out in nature).

The most important aspect of caring for your paintbrushes concerns getting paint on—and into—your brush. If you treat your brush well, it will last. If you don't, it will soon lose its edge or point. Step one in using any brush is to get it damp. Dip the brush bristles completely into a container of water. Gently press the brush against the inside of the container, forcing the water into the brush. Now, pull the brush against the lip of your water container, forcing out most of the water. Remember: Always pull your brush in the same direction as the end of the bristles, not against them!

Next, get paint onto your brush. If you are using the brush to mix two colors, make overlapping cross motions, each rotating on top of the last, to mix your paint well. This also works the paint into the brush. Make sure you turn the brush so that all sides get the paint. If you don't, one color will tend to build up on one side. You may want to use a stiff brush for mixing the paint, then shift to a softer one for applying it to your landscape.

Once the paint is mixed, weed the brush. Weeding the brush simply means pulling all the excess paint toward the end of your brush. This is especially important when using a fine-detail brush. Lay the brush nearly flat against the palette and twist and pull the bristles so the paint leaves a trail out the top of the brush.

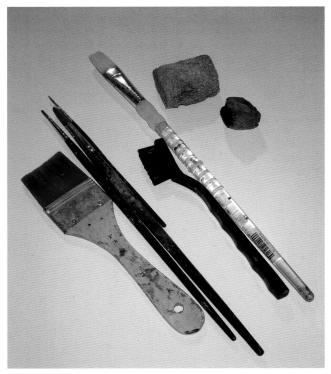

An assortment of brushes will help you with a wide variety of techniques, as will some "alternative" painting tools like sponges and toothbrushes.

If your brush drags or your paint skips, your brush is telling you it's thirsty. Get a little more paint into the brush. If the paint is too thick, water it down. Dip the tip of your brush into the water, then bring the brush back to your palette to weed it, working the water into the brush. If you don't weed the water into the bristles, it will simply stay as an outer layer on the brush. It usually drips or blobs and ruins a perfectly nice painting, so work it in! Paint consistency is more important than the sized of the brush. I can get a fine detail line with a medium-sized brush if the paint is the right consistency, but with thick paint, even a detail brush will give me an inconsistent line.

Sometimes, a color is almost what we want, but just a little off. In these cases, we can use a "wash" to shift the color. A wash is the use of watered-down paint to tint the picture. Use a soft brush to apply a translucent layer of paint. Always make sure your wash is dry before moving on to other steps.

Weeding the brush.

WORKING WITH COLOR

Now that you've got paint on your brush, let's talk briefly about color. Each color has a different strength. Black is the strongest; white and yellow are weakest. When mixing colors, always add a little of the stronger color to the weaker one. For example, to mix cadmium yellow and phthalo blue, put a dime-sized blob of cadmium yellow paint on your palette.

Next to it—but not touching—put a dime-sized blob of blue. I call these initial piles of paint "primary blobs" (a highly technical term). Always mix away from your primary blobs. Using your medium-sized round brush, take a blob of yellow and place it on a clean area of your palette. Now, take a much smaller blob of the blue and mix it into the yellow. See how dramatically the color changes? Had we tried to put yellow into the blue, the change would not have been so marked, and we would have ended up using much more paint.

Notice how there are two kinds of red and blue on our list. Phthalocyanine blue has green in it, so it mixes well with yellow and green tones. Ultramarine blue has red in it, so it tends toward the purple. Cadmium red has yellow in it, while acra violet (alizarin crimson) has blue, so it tends toward the purple end of the palette.

Pay attention to the colors you mix into these paints. For example, if you try to use phthalo blue mixed with cadmium red for a sunset, you'll get a muddy sunset. The reason: The green in your phthalo blue mixes with red—its opposite color—to make a muddy gray. Instead, use ultramarine blue, which already tends toward red, for a clean sunset.

Mixing paints is a great way to learn about color. Spend some time experimenting, always cleaning your brush before changing from stronger to weaker colors. To get the hang of mixing and applying paint, we'll do a few skies.

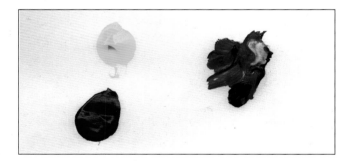

My "primary blobs" of cadmium yellow and phthalo blue and the resulting green they make when combined. Always add small amounts of the stronger color to the weaker to avoid having to mix huge amounts of paint.

BASIC COLOR THEORY

Color theory is a complicated topic, about which entire books have been written. This discussion is meant to give you a basic overview that will help you understand terms and concepts mentioned in this book.

PRIMARY COLORS are colors that cannot be mixed from other colors. Red, blue, and yellow are the three primary colors. Combining two primary colors creates a **SECONDARY COLOR.** Red and blue make violet, red and yellow make orange, and blue and yellow make green. **TERTIARY COLORS** are formed by combining a primary and a secondary color. Red-orange, blue-green, yellow-green, and so forth, are tertiary colors.

An easy way to understand how colors relate to each other is by arranging them in a color wheel. **COMPLEMENTARY COLORS** are directly opposite each other on the color wheel. Red and green, for example, are complements. Mixing a color with a bit of its complement dulls it. Mixing equal amounts of complementary colors creates a dull brown, or "mud." Placing complementary colors next to each other creates contrast. You can either use a little bit of a color's complement to add interest to a composition or place equal amounts next to each other to make them compete. The choice is yours.

Colors have properties that you need to understand in order to successfully use them in your paintings. These are value, temperature, and intensity. **VALUE** refers to the lightness or darkness of a color. Adding white to a color will lighten it, creating a tint, while adding black will darken it, creating a shade. **TEMPERATURE** refers to the warmness or coolness of a color. Warm colors (reds, oranges, and yellows) tend to advance. They are energetic, passionate colors. Cool colors (blues, greens, and violets) tend to recede. They are quiet, restful colors. To make matters more complicated, you can have warm and cool varieties of any color. For example, some reds have more blue in them and are therefore considered cooler, while some reds have more yellow in them and are warmer. **INTENSITY** (also called **SATURATION**) refers to the brightness or dullness of a color. Mixing a color with its complement reduces its intensity.

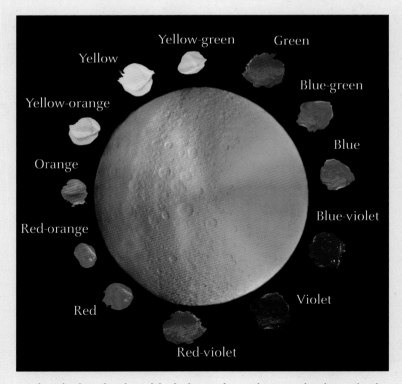

A color wheel is a handy tool for looking at how colors are related to each other.

PURE COLOR IN PAINT: THERE ISN'T ANY!

When mixing paint colors, you have choices to make. If you want to use blue, do you choose ultramarine blue or phthalo? If you want to use red, do you use acra violet or cadmium red? The problem is that there is no such thing as a pure blue or red paint.

Cadmium red contains yellow, while acra violet and the crimsons (for example, alizarin and naphthol) have a little blue, which sends them toward the purple end of the spectrum. If you try to mix red and yellow to paint an orange sunset using acra violet, the blue in your "red" paint will mix with the yellow of your orange. Yellow and blue make green, which is the opposite of red on the color wheel. When you mix opposite colors, you get that color technically referred to as "mud." So, for orange skies, use cadmium, and for purple scenes, use violets/crimsons.

This phenomenon of impure paint also occurs in the blues. Ultramarine and cobalt blues contain a bit of red, sending them toward purple hues. But phthalocyanine blue contains green. In a sunset, you want to use ultramarine or cobalt near your red-orange sunset glow, since the green found in phthalo will do nasty things with your red sky.

Pay attention to the secondary colors you mix into these paints. For example, if you try to use phthalo blue mixed with cadmium red for a sunset, you'll get a muddy sunset. The reason: The green in your phthalo blue mixes with red, its opposite color, to make a muddy gray. Instead, use ultramarine blue, which already tends toward red, for a clean sunset.

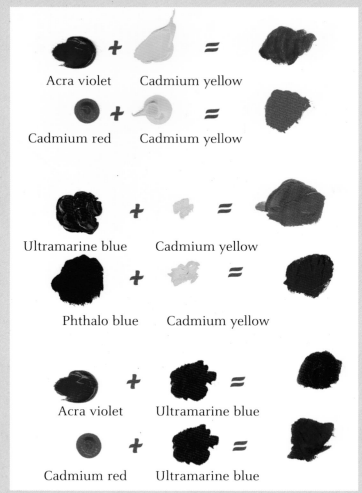

Acra violet + Cadmium yellow =

Cadmium red + Cadmium yellow =

Ultramarine blue + Cadmium yellow =

Phthalo blue + Cadmium yellow =

Acra violet + Ultramarine blue =

Cadmium red + Ultramarine blue =

Cadmium red mixed with cadmium yellow yields a more pure orange than acra violet mixed with cadmium yellow does. Phthalo blue provides a more pure green when mixed with yellow than does ultramarine (or cobalt) blue, which yields a green closer to sap or Hooker's green (more neutral). Finally, acra violet mixed with ultramarine blue gives a more pure purple than does cadmium red, which tends toward the "mud" end of the spectrum.

PAINTING AN EARTH SKY

The most important thing to do when painting a sky is to observe and learn from nature. Go outside and look at the sky (or at least look at a photo). No matter what color it is, what do you notice about the horizon (the line between earth and sky)? Compare the color to the sky higher up. Unless you are looking directly toward the sun, the sky on the horizon will always be lighter. The reason is that we are looking through more atmosphere at the horizon. Directly overhead, the air is about 100 miles thick. But the sky above the horizon is many hundreds of miles in distance. Let's try painting an Earth sky on a clear, sunny day. We're going to use a combination of phthalo blue, raw sienna, and titanium white.

Step 01 First, dampen your large flat brush and brush a thin layer of water over your canvas to keep the paint from drying too fast. Do not use so much water that you get beads and puddles! Remember: Even with a damp canvas, you'll need to keep that paint moving; acrylics dry quickly!

Put a line of phthalo blue on top, seasoned with a few dabs of white. Beneath this, about halfway down, place a little more blue and white, adding a couple splashes of raw sienna. Below that, you want mostly white, because the sky at the bottom must be brighter than anything above. Cut the white with just a bit of sienna to warm it up. Your color should end up being fairly neutral when it's mixed together. Put a bead of pure white at the bottom.

Step 02 The next step is to push the paint horizontally across the canvas. Rather than taking long simple strokes, wiggle the brush up and down as you pull across. As you do this, your paint will begin to mix together.

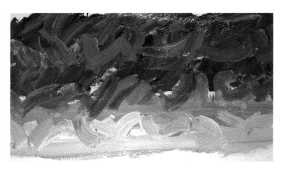

Step 03 But wiggling the brush won't mix the paint enough. You must take out one of our secret weapons: the X stroke! Use this stroke at the borders of each band of color, crossing from one color into the other in X-shaped strokes. This stroke mixes the paint in a vertical direction, so that you can create a more even gradation from top to bottom.

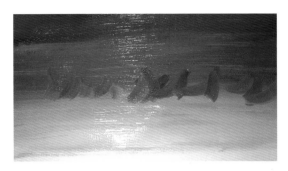

Step 04 Now, use your large flat brush, slightly damp, to pull strokes the full length of the canvas. Make sure to carry the paint all the way off the edges, making a smooth horizontal stroke each time. Move from lightest to darkest. Do not go back unless you clean your brush first! If you do, you'll contaminate the lighter colors with the darker ones. In some areas, the paint may not mix evenly. Don't worry: Just go over that area with your X strokes and redo it.

Step 05 Here is the finished sky. When doing a large area, it is of utmost importance to mix enough paint. You want it to go on thick. If the paint becomes too thin, your canvas will begin to show through as your brush strokes scrape through the paint. It is better to err on the generous side. Just make sure the paint is well mixed with your X strokes.

PAINTING AN ALIEN SKY

Now that you've mastered how to paint an Earth sky, let's try painting some alien skies. To paint an alien sky, you can use the same techniques you learned above to paint an Earth sky, but vary the colors. The atmospheres on different planets contain different gases, which change the color of the sky. Be creative! If you're painting the sky of an imaginary world you can really go crazy with the colors. If you want, you can block in a color at the bottom of your canvas for the land, too.

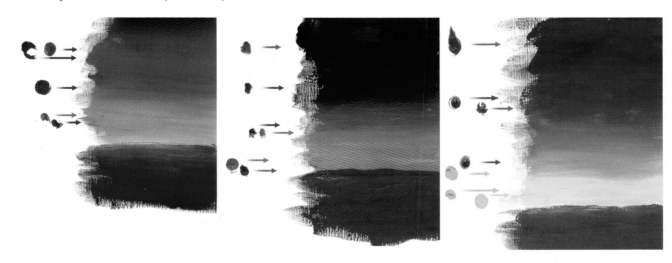

Here are some color combinations you could use to paint alien skies: dioxazine purple, ultramarine blue, and raw sienna (*left*); dioxazine purple (more than in the first example), ultramarine blue, raw sienna, and acra violet (*middle*); Hooker's green, phthalo blue, yellow ochre, and cadmium yellow (*right*). I always add smatterings of white, as I did when painting an Earth sky.

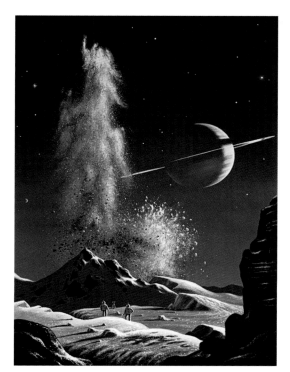

MINING OPERATIONS ON TITAN
BY DAVID A. HARDY

Scientists once thought Saturn's moon Titan's air was thin methane. This atmosphere might have made for beautiful green skies, as seen in this painting. (David A. Hardy/www.astroart.org)

WHY THE SKY IS BLUE . . . OR GREEN . . . OR PURPLE . . .

After a rainstorm, when the sun is directly behind us, we can see the glorious colors of the rainbow. Those colors are always there, bouncing around the molecules of air above us. Raindrops in the air split up the light into a spectrum of different colors. Each color has a different wavelength of light. Red is the longest wave, and violet is shortest. Our air is made up of nitrogen and oxygen, with just a bit of water vapor, carbon dioxide, and other gases. This combination of gases tends to scatter blue light. All the colors of the rainbow travel through the air, but as the light shoots through the molecules of air, the longer wavelength tend to get through, while the blue is absorbed by the molecules. The blue light is then bounced back at lots of different angles. When we look into the sky, we're seeing this bounced light. At sunset, when the light must travel farther to get to us, it is mostly the longest (reddest) wavelengths that get through.

On other worlds, the skies are tinted by a different mixture of gases. For example, a planet with chlorine or methane gas might have a greenish sky. The sky on Mars is tan because of suspended dust in the air. The air on Saturn's moon Titan is almost completely nitrogen and is the color of tomato soup!

DOME BY MICHAEL CARROLL

I painted this scene with a vivid red alien sky for the cover of the book *The Siege of Dome* by Stephen Lawhead (Zondervan, 1996). (Reprinted by permission of the publisher)

NEAR EARTH ASTEROID BY MICHAEL CARROLL

TWO

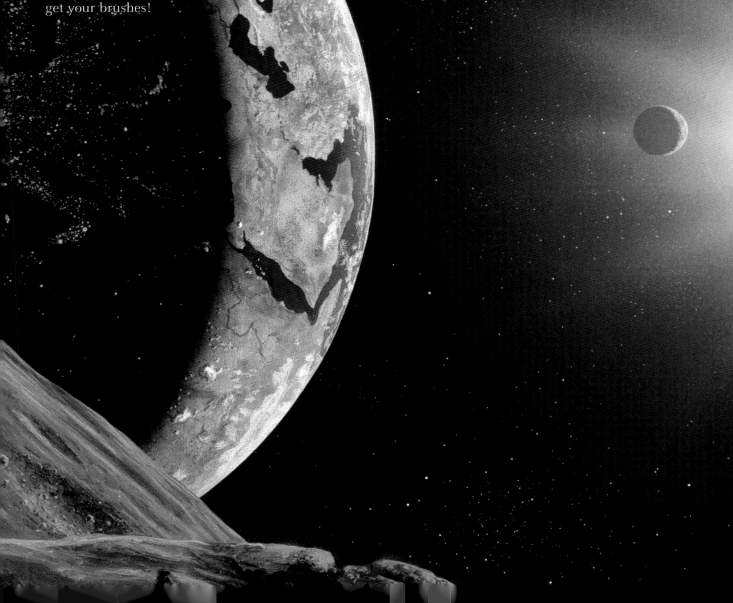

THE EARTH-LIKE WORLDS

Mercury, Venus, Earth, and Mars, the four planets closest to the Sun, are smallish worlds of rock and metal. Together, they are known as the terrestrial (or Earth-like) planets.

Just like a good restaurant, Mercury, Venus, and Mars all have atmosphere. Venus has the most and Mars the least. Atmosphere means weather, and weather means erosion. Wind and water (and, in the case of Venus, acid) sculpt and wear away the face of these worlds, carving rivers and canyons, grinding rock into sand dunes. Internal forces lift mountains and spout volcanoes. Mercury, which is closest to the Sun, has no air, so its landscape is very much like our moon. Like all solid-surfaced planets, meteors have scarred its face, leaving deep craters. They all have craters, but the more atmosphere, and the more weather, a planet has, the fewer meteors hit the planet, and the fewer craters survive.

There's a lot going on across those terrestrial planets. Let's venture into the inner solar system. Don't forget your brushes!

THE EARTH FROM THE MOON

LEVEL: BEGINNER

For our first space painting, we'll stay close to home. We'll learn some critical basics of not only space painting but also landscape painting in general.

The Moon is the only celestial site that has been visited by human beings. Twelve people have walked, bounced, and driven across the Moon's dusty plains. Astronauts have explored craters, peered into canyons, and climbed mountains. Samples of the Moon's rock and soil have also been returned by Soviet robots.

The Moon is an airless world with sunlit temperatures above 230°F and temperatures in the shadows dropping below −275°F. Vast craters span its surface, some filled with dark material. These lunar plains were once thought to be oceans, so features on the Moon have names like the Bay of Rainbows, the Lake of Time, and the Ocean of Storms, but the only oceans that the Moon ever had were oceans of molten rock. The dark patches on the face of the Moon are the scars of those ancient seas of lava.

The Moon offers a spectacular view of Earth, which covers four times as much of the lunar sky as a full moon covers on an earthly evening. We'll exaggerate this size a bit to make our composition even more dramatic. Let's bask in the hot afternoon sunlight as we paint a moonscape.

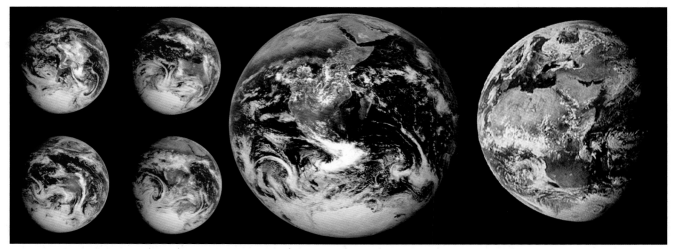

Before you begin your painting, take a look at some reference photos. The four views at left were taken by the *Galileo* spacecraft on its way to Jupiter. The other two images were taken by *Apollo* astronauts on their way to or from the Moon. Notice how the clouds are very bright against the blue oceans, and the continents fade away here and there, so that not every coastline is defined. (Photos courtesy NASA/JPL)

The Plan Our sky will take up about two-thirds of the our canvas. Earth will float close to the horizon and a little right of center. To offset the heavy Earth to the right, we'll put a dramatic rocky outcrop along the left side. Since there is no atmosphere on the Moon, the sky will be black.

Step 01 Cover the top two-thirds of your canvas with Mars black (nobody seems to make "Moon black"). Use long, horizontal strokes that travel completely off both sides of your canvas. Keep your paint wet enough to go on smoothly, but not so wet that the white canvas begins to show through. Let your sky dry completely (you can speed this process with a hair dryer).

You're about to learn about a fundamental secret weapon of any great space artist: the toothbrush starfield! Spread some white paint onto the surface of your palette, watering it down to the consistency of white glue. If the paint is too thin, it will not show up against the black. If it's too thick, it will leave little strings between the blobs of white. Dip the ends of a toothbrush into the paint. Holding the toothbrush a few inches away from your canvas, bristles down, point the front end of the toothbrush in the direction of the canvas and flick the bristles with your thumb. Pull your thumb toward you—front to back—or you'll spray yourself! Don't put in too many stars. You want lots of black space to show in your sky.

Step 02 To paint Earth, first, put down a coat of blue using two parts ultramarine blue, one part phthalo blue, and two parts white.

Step 03 Add washes of browns and tans to the blue surface, allowing them to fade away here and there. Try to define a few recognizable areas of continents, but remember that clouds will cover a lot of what you put down.

Step 04 Put a wash of equal parts black and dioxazine purple over the left edge of your Earth to define the night side. After this wash is dry, add a second wash of pure black just along the edge against the sky. You want the edge of the Earth to fade away softly into the sky. Keep the night edge very even or your planet will look lumpy. This is a very important space art rule: no lumpy Earths!

Step 05 Dampen a sponge (preferably a fine natural one with very small holes), squeezing out all the excess water. Dip the sponge into titanium white paint on your palette. Now, drag the sponge gently across the Earth, leaving lots of area untouched.

Next, use a detail brush to line the sunlit (right) side of the planet. Keep the edge against the sky very firm, but tap the inner part of the line so that the white paint blurs as it reaches across the ocean. Always paint a circular line or object from the inside out, following the natural motion of your wrist. You can get a much cleaner line by painting in this direction. You may have to turn your painting upside down to do this.

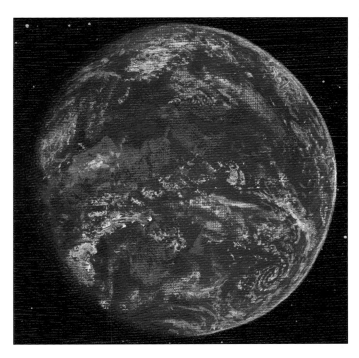

Step 06 Paint in some swirls of storms and hurricanes. Note that the storms must fade out as they reach the soft shadow (the terminator) on the left side of your Earth. Add a little phthalo blue to raw sienna and put in some green areas to complete your Earth.

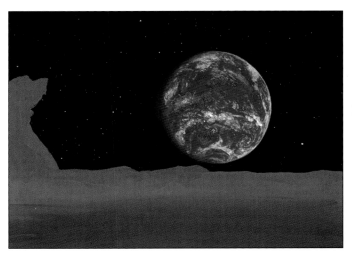

Step 07 Mix some white and black and lay in a gray base coat across the landscape. Under most lighting conditions, the lunar landscape is very gray, so use more white than black to keep it from getting too dark. If you want to add a darker value to the lower foreground, use your X strokes to blend it in.

Step 08 For this step, you'll use the wonderful and highly technical artist's tool known as the common kitchen sponge. An artificial sponge is great for making rock textures. Mix a nearly black color for your shadows and water it down to the consistency of white glue. Dampen your sponge, but get rid of any excess water. Dab the sponge into the paint, with the flat face of the sponge against the palette. Gently press the sponge face onto your canvas in areas that you want to turn into rocks and boulders (*left*). Press the sponge down only once in each place or you'll wipe out your detail. Be sure to turn the sponge each time so you get a different set of textures.

Using very light gray paint, add highlights to the tops of your rocks (*center*). Once the sponge textures are down, apply washes with a detail brush to firm up the edges (*right*). For more on painting sponge rocks, see "Painting Rocks" on page 52.

Step 09 Trim a sheet of tracing paper with scissors or a craft knife to cover the sky and the area on the left where the slope will be (*top*). Get out your toothbrush again. Add some white to your highlight color so it's even brighter and water it down to the same consistency you used for the stars. Flicking really wet paint over the foreground gives you big "gravel." Each time your toothbrush begins to lose paint, take advantage of the ever-shrinking drops, putting them farther up the landscape to give the effect of more distant gravel. While the paint is still wet, wipe it off the rocks that you put in during step 8. A few pebbles showing through won't hurt a thing. After nearly saturating the landscape with highlights, reinforce the effect with shadow. Repeat the process you just did while using dark paint (black cut with just enough white to make it dark gray). Keep your paint wet, so it will randomly blob together.

Step 10 Add shadows and highlights of craters here and there. (See step 7 of "A Landscape on Mercury" on page 47 for a detailed account of rendering craters.) Lay a clean sheet of paper, trimmed with a slight curve, over the right side of your canvas, leaving just enough exposed canvas at left to make a foreground slope. Add gravel to this slope with the big blobs from your toothbrush. Once the texture is dry, add a highlight to the edge and soft shadows underneath the rocks. Add horizontal highlights to the distant landscape, with the soft lines getting closer to each other as they approach the horizon. Throw in a few larger blobs of light color with shadowed sides for medium rocks and boulders. Your first space painting is finished!

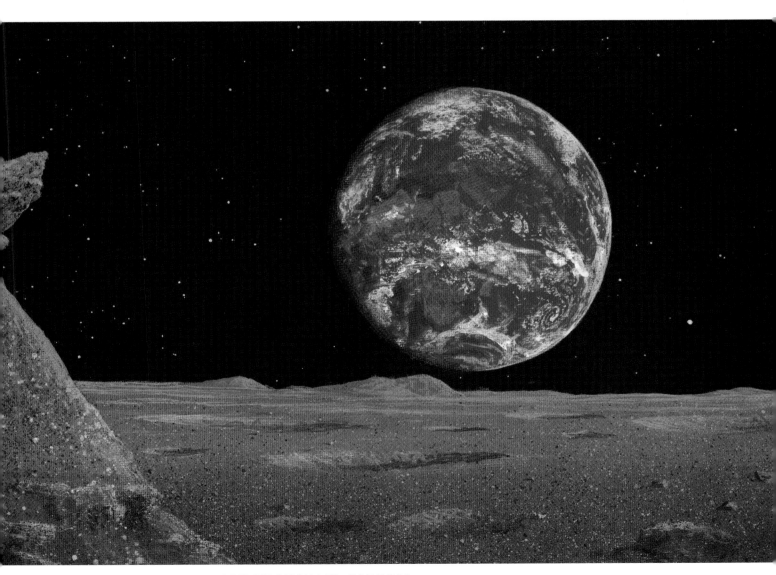

THE EARTH FROM THE MOON **BY MICHAEL CARROLL**

A LANDSCAPE ON MERCURY

LEVEL: BEGINNER

Now let's pay a cosmic visit to the planet closest to the Sun: Mercury. While not the hottest planet (Venus is hotter because of its blanket of dense atmosphere), Mercury's lunchtime temperatures still climb up around 800°F. From the battered landscape of Mercury, the Sun appears nearly three times as large as it does in our own sky. Its surface is cratered, much like the Moon's, but the ground is slightly redder. Mercury has a heart of iron; it's one of the densest worlds in the solar system. Mercury has long cliffs that wander across its desolate plains. These dramatic walls of stone are called rupes. That's where we'll sit down with our canvas and "paint a spell."

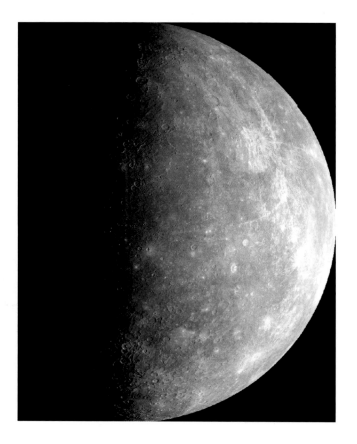

The battered face of Mercury reminds us of the Moon in this photo sent back by the *Mariner 10* spacecraft. It flew by Mercury three different times, beginning in 1974. (Photo courtesy NASA/JPL)

The Plan With the Sun so large in the sky, it will be a dramatic part of our painting. Because it will be peeking just over the horizon, remember that the shadows will be pointing away from it, toward us. It's a good rule of composition not to put the horizon right in the middle of the canvas. We'll put it one-third of the way down from the top to give us lots of room to paint our landscape.

Step 01 First, cover your surface with a thin veneer of equal parts raw sienna and titanium white. When the paint is dry, sketch in our dramatic rock wall. If the painting is to be balanced, something must offset that wall on the other side of your landscape. The Sun should do the trick.

Mix a warm suite of colors—cadmium red, cadmium yellow, and raw sienna—and apply it to the future site of the Sun. Ring it with pure cadmium red, which will help the bright area "fade to black" without the yellow in your paint turning green (black plus yellow often makes green). Cover the rest of the sky with Mars black. Gently brush the lighter color into the dark, washing the brush often. Keep moving! The paint will dry quickly, and you must finish blending before it gets too thick.

Step 02 Once your glow is dry, water down some black paint and go over the bright area with a thin wash (*right*). This will soften the glow, making it less pronounced. To hide the brushstrokes, blend with a soft brush or even your finger, which is a great built-in painting tool.

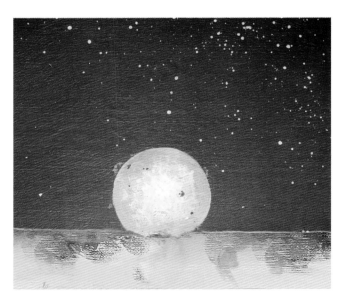

Step 03 Before you paint the Sun, put in a starfield using a toothbrush dipped in white paint. (See step 1 of "The Earth from the Moon" on page 39 for more on applying paint with a toothbrush.)

When the ground is completely dry, you can paint your sun. Using a white pencil, trace a round object, such as a jar lid or lens cap, or use a circle template. To give the illusion of a glowing object, the edges must be darker than the middle. Make the edge of the Sun yellow and raw sienna (equal parts of these with some white) blending to a white-hot center. While the paint is still wet, daub some small, black blobs on it here and there for sunspots. Work the black in so that the spots are faint. To finish your Sun, put some bright solar flares on the edge. These should be small, subtle, and hot pink (acra violet and white). Believe it or not, the flares on the Sun are a bizarre, Day-Glo pink to the naked eye.

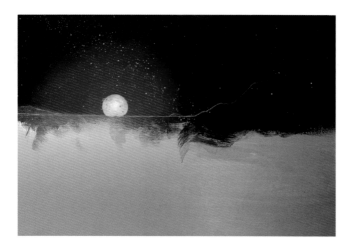

Step 04 It's time to block in your landscape, which will be essentially reddish-gray. You'll use colors that might surprise you: white combined with burnt sienna and ultramarine blue. The combination of these colors creates a wide range of neutral blues and browns. Try mixing the three colors on your palette. When you get something a bit more red than blue, and in the mid-value range (not too dark, not too light), you've arrived at your Mercury color. Add just a bit of raw sienna and fill in your landscape, adding just a bit of black as your color comes down so that the ground darkens as it comes close to the viewer (use those trusty X strokes).

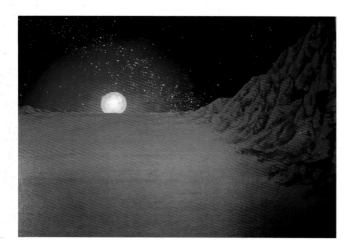

Step 05 Now, drop in shadows that are nearly black, cut with burnt sienna. Use linear strokes that parallel the slanted face of your rupes: wider lines for thicker plates of rock, thin ones for cracks. Note how the shadows are laid in just ahead of each big "bump" against the sky, so that the shadow defines the ridge next to it. Some lines are soft and rounded; others are hard-edged and geometric. Notice how each shadow starts from a firm dark line and breaks up as it moves toward the sunward side. Soften some of your lines by tapping them with your finger.

Finish off your cliff shadows by applying shadow color with a sponge. Gently place the edge of your sponge against some of your shadows to extend the brushwork into a rough texture. Push the sponge down only once for each site, as multiple imprints will obliterate your detail.

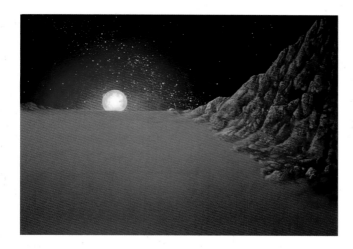

Step 06 To add highlights, sponge on a 50/50 mix of raw sienna and white. Feel free to add more white as needed, especially toward the distant part of the cliff. Once the sponge highlights and shadows are in, use your detail brush to meld some of the textures together.

With a detail brush, add more highlights. Your highlights must be adjacent to each shadow, but on the side facing the Sun. No one really knows what rupes look like, so we're doing some guesswork. Make each crag and crevice different from the last. As your paintbrush moves toward the horizon, the detail should become less pronounced. The drier your brush, the more fuzzy the lines will be. If you want a fine line, thin the paint. To add distant hills to the left side of the Sun, use the same technique in mirror image.

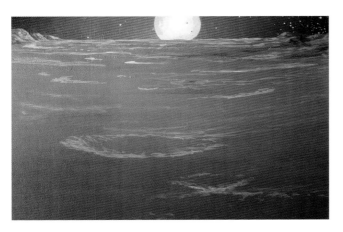

Step 07 Review the discussion of craters on page 21 to place some craters. Using the same colors as you did on the cliff, define the highlights, then the shadows. Toward the horizon the craters should become simple lines.

Cover the sky and the top half of the cliff with tracing paper. Add some white to your highlight color and water it down to the consistency you used for the stars. Spray some gravel over your landscape. Once it's dry, put in some cast shadows. Add a few larger blobs for rocks, and paint a wash of dark paint over the craters to reinforce them as needed. Tap with your finger to remove some of the paint from the surface to let the gravel shine through. You're left with a spectacular, baking landscape of Mercury.

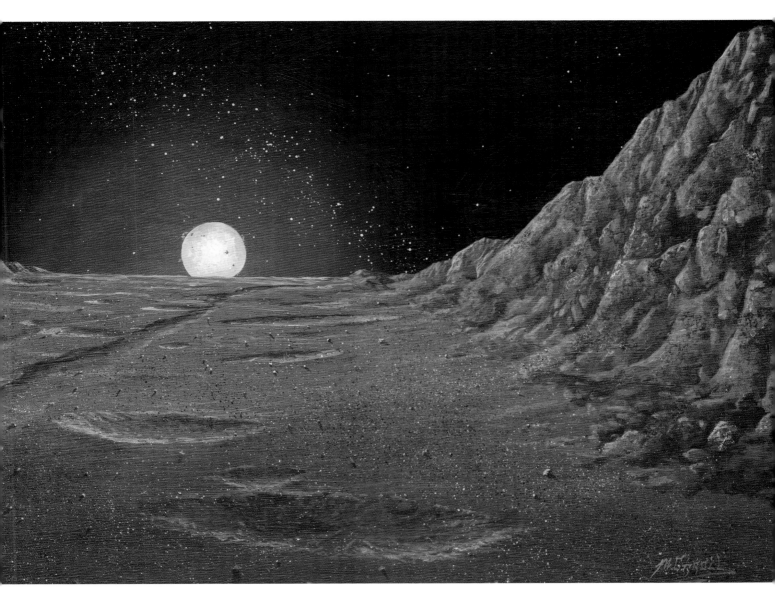

A LANDSCAPE ON MERCURY **BY MICHAEL CARROLL**

A VENUSIAN VOLCANO

LEVEL: BEGINNER TO INTERMEDIATE

For this painting, you'll be using illustration board. Sketch your composition in detail on a piece of tracing paper the same size as your final painting. You will transfer your sketch after you put down some foundational paint. If you use canvas instead, put off your pencil sketch until you cover your canvas with a layer of gesso. Let it dry and sand it to a somewhat smoother finish.

Before starting, let's take a look at our subject matter. Volcanic mountains, fissures, and lava flows have resurfaced fully 90 percent of the Venusian landscape. Venus has volcanoes of many shapes and descriptions. Scientists refer to this geologic menagerie with labels like "anemones," "ticks," "arachnoids," and even "pancakes." Our painting is going to depict a tick as seen from the surrounding plains.

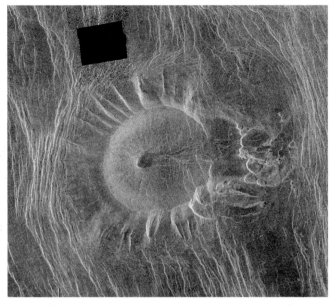

Use this image, taken by radar aboard the *Magellan* spacecraft, as a reference for your Venusian volcano. Notice how the flanks, or sides, of the volcano are lined by ribs of debris that have slipped downslope. These will make for a dramatic scene. (The black rectangle is data that are missing; who knows what mysteries lie just outside our view!) (*Magellan* image P37789, courtesy NASA/JPL)

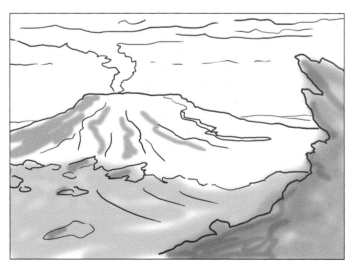

The Plan You'll be looking across the rolling plains of Venus toward your "tick" volcano. A column of smoke trails into the eternally overcast sky. Lava is just visible snaking down the slopes toward the right. In the middle ground, successive hills define distance. We are perched on a rocky outcrop in the foreground.

Step 01 Unlike canvas, illustration board must have a border for framing. Mask the border with tape. Applying gesso to the board (or canvas) gives it some "tooth" for the paint to stick to and also affords you the opportunity to tint the surface. Using a ratio of four parts white gesso, one part raw sienna, and one part yellow ochre thinned with water, brush a thin veneer of gesso over the surface. When this is dry, draw in your horizon line, referring to your sketch.

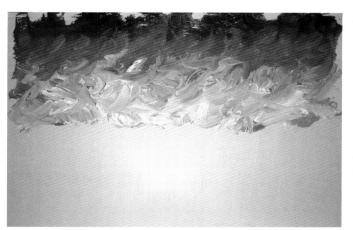

Step 02 Begin with an alien sky. Your horizon line will be one-third of the way down from the top. Start with the brightest part of the sky, just at the horizon. Using a ratio of three parts white, one part raw sienna, and one part yellow ochre, blend the color with X strokes. As you reach the halfway point of your sky, add more raw sienna and a touch of yellow ochre. Near the top, work in some dioxazine purple and more raw sienna (in about a 1:2 ratio). Blend the zones of ever-darkening paint with X strokes, and then use a flat, soft brush to blend the entire sky into a smooth gradation. Use water as needed to keep that paint flowing.

Step 03 Venus is completely overcast all the time, and from the surface it is likely that we would see subtle cloud structure. After the paint dries, use a soft round brush with a very thin mix (consistency of ink or white glue) of half dioxazine purple and half raw sienna to drop in some subtle clouds. Keep this texture very linear and horizontal, darkening the hollows to create soft bumps that face upward. Brush each bump softly downward until it disappears. Keep your colors subtle: When you add these dark areas, you should have difficulty seeing the difference between the new color and what's already on the sky. Turn your board upside down and use the same process with thin, yellow ochre highlights against the shadows, making light, upside-down "hills."

Step 04 Now, transfer your sketch to the painting board. Put charcoal or white chalk all over the back of the drawing, tape it to your board (with the sketch side up and chalk against the board) and trace with a ball-point pen or hard pencil. When you peel the paper away, the lines will magically appear on your painting surface. You may want to go over them again with pencil so they are clear.

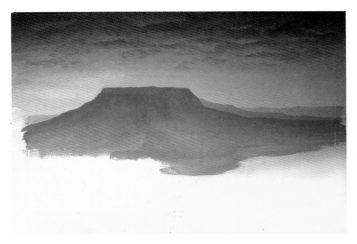

Step 05 It's time to put in some distant mountains. On Venus, the air is hazy, so these mountains will take on the sky color. Your horizon should be fairly flat, with some low-lying hills. Create a gray by adding a bit of black to white, raw sienna, and yellow ochre. Lay in a strip of this color on the distant horizon using a soft, medium-round brush. Keep it moist to get a good edge.

Add a closer layer of gray. This layer includes the tick volcano, rising at left. It can have a few more bumps and more ragged relief. At the base of this layer, add a little raw sienna, yellow ochre, and a touch of white, blending these up to create the illusion of low-lying fog. Don't bring this lightness up too far or you will lose the contrast with the layer behind. Let the lighter base fade into the dark landscape.

Step 06 Using a detail brush, put in a few random highlights on the far and middle layers. Highlights on the distant hills should be faint.

ATMOSPHERIC PERSPECTIVE

As objects get farther away from the viewer, their color shifts toward the color of the sky. This phenomenon is called atmospheric perspective. What's happening is that the viewer is observing landscapes through many layers of air, and this air tints the landscape. The more air we look through, the more the landscape is tinted with the air color.

 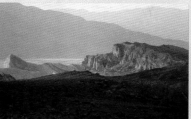

Here are three examples of atmospheric perspective. At left is a misty landscape in the Landmannalaugar region of Iceland. At center is a view of successive ridges in Death Valley. At right is the Neuschwanstein Castle in Bavaria. (Photos by author)

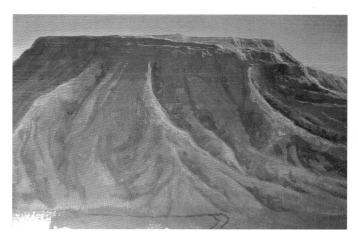

Step 07 Details, details! Take a look at the *Magellan* image of the tick volcano on page 48. The flat-topped volcano leans a little to the right—you can tell by the way lava has flowed from the crater at its center—and has armlike ridges of debris radiating out all around it. Each of these ridges in your painting will need to be textured. First, use highlights to define the ridges on the flank of your volcano, always keeping your paint thin so you can tap it out with your finger. Shadows come next. As you did with Mercury, let the shadows define the highlights, laying one against the other. Each layer gains more detail as it gets close to the viewer. Your shadows should be subtle. Don't put shadows on the farthest ridge; this gives the effect of fading into the distance.

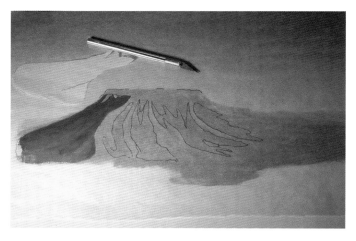

Step 08 Mask the volcano with tracing paper, cutting out any highlighted areas.

Step 09 Using a very dry toothbrush so the spray is fine, apply light gravel to the unmasked areas. Repeat the process to apply dark gravel to the shadowed areas. Add washes of highlight and shadow after the spatters are dry. Keep the contrast low; this mountain is far away!

Now that your tick is in place, paint in the closest ridge, making it reach all the way to the bottom of the image. Add ground fog to this ridge as you did in step 5.

Optional: Tap a moist sponge across the wet surface to texture it a bit. Also, using thin washes, you can add some hints of ridges between the foreground and the distant tick.

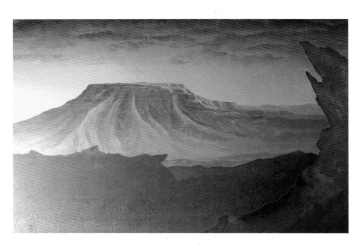

Step 10 When the paint is dry, drop in the closest rock outcrop. Give the closest layer a little more black and some burnt sienna for color. Feeling adventurous? Try adding a touch of purple. While your paint is wet, tap the top rocks with a damp sponge to give them some roughness.

PAINTING ROCKS

Making rocks with a sponge is an easy and versatile technique. Let's assume our light is coming from the right, as it is in this painting of Venus. First, wet your sponge with dark paint and press the surface of the sponge against the canvas or board where you want your rock to be. Repeat this process just to the right of your shadowed area, using highlight color. Let the sponge textures overlap in the middle. As in nature, the shadows and highlights will play and intermingle with each other at the center.

Now, take the shadow color and softly brush it onto the far left edge, making a solid left edge for the stone. Use a brush to edge the sunlit side with the highlight color. I call this "firming up" the rock, giving it dimension and shape. When sponging large areas, make sure to turn your sponge and rock it from side to side before each pressing so that you don't repeat the same patterns. Each sponge pressing must use a slightly different part of the sponge. Remember the randomness of nature!

Step 11 Put in shadows on a series of foreground rocks wherever you want, using the sponge technique described in "Painting Rocks" on the previous page. After these shadows are in, spray on dark gravel texture across the ridge. Since the rocks will have highlights after this, you don't have to be too neat. Make sure to mask off the background behind this ridge. After putting light gravel over the dark, overlay sponge highlights and firm up the rock edges.

Step 12 Bump up the lights and darks on the closest outcrop. You want it to look like it's right in front of you. After sponging and firming up the boulders on top, mask the bottom slope under your foreground rocks and have at it with your toothbrush. Use the same technique as you did on Mercury, but use more paint and more water, laying on very thick texture. The droplets will randomly blob together into small rocks. Add shadows and highlights on some of the larger chunks of gravel.

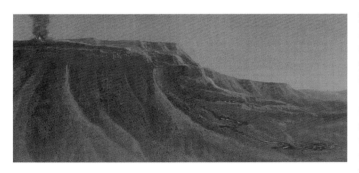

Step 13 It's time for a little excitement. First, rub on a hint of smoke issuing from the top of the volcano. Use a mix of volcano gray with sky purple and raw sienna. As your smoke rises into the sky, it fades out. Move your brush or finger in a circular motion to make billowy forms.

Using a detail brush, lay in a fountain of cadmium red against the base of your smoke column. Tap it a bit so it looks distant. Let more red cascade down between two ridges, snaking its way across rocks and ravines, thin in places, thick in others. Mix hints of cadmium yellow into the still-wet red.

WHAT THE *VENERA* LANDERS SAW ON VENUS

In the 1970s and 1980s, the Soviet Union launched a successful series of probes, called the *Venera* landers, to the surface of Venus. Six of them returned photos of their surroundings before succumbing to the crushing Venusian furnace. Several landed on fairly flat ground with platelike rocks. *Venera 9* landed on the side of a steep hill, perhaps the flank of a volcano. The glimpses these craft radioed to Earth showed us a simmering desert planet. For the space artist, these thrilling snapshots help us to more accurately paint landscapes of this alien world.

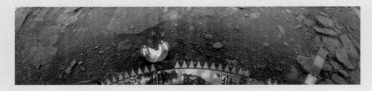

This strange landscape, warped by the camera system on the Soviet *Venera* lander, shows the horizon at both corners of the panorama. The closest rocks are at the center of the image. The sawtoothed form at center is the landing platform of the *Venera* craft. (Courtesy Don P. Mitchell)

VENUSIAN VOLCANO BY MICHAEL CARROLL

Peel off the tape for a nice, clean edge. This helps the framer to cut a mat to fit your work of art before it goes to the Guggenheim. We learned a lot of new techniques in this painting that we'll use in the lessons on the worlds to come.

GUEST ARTIST
PAINTING VOLCANOES BY DAVID A. HARDY

When I was very young my parents were wise enough to buy (at great expense, I'm sure) a set of encyclopedias. The most well-thumbed pages were those with photographs of the Moon's craters, Saturn's rings, erupting volcanoes, steaming geysers, and bubbling mud pots. It is hardly surprising that I have retained an interest in geology and volcanology, as well as astronomy. As soon as I was able, I visited some of our planet's volcanic areas, such as Iceland and Hawaii, and in 1991 I produced a book about volcanoes entitled *The Fires Within: Volcanoes on Earth and Other Planets* (Dragon's World).

It has always seemed to me that these subjects go hand-in-hand, and as I met other space artists, it became clear that others feel the same. There is an "alienness" about these areas, not unlike our visions of alien worlds.

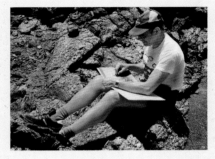

David Hardy sketching in Hawaii. (From *Hardyware: The Art of David A Hardy*, Paper Tiger/Sterling, 2001).

As probes ventured farther into space, we discovered that there are indeed giant, probably extinct volcanoes on Mars and Venus, highly active ones on Jupiter's moon Io, and geysers on Saturn's moon Enceladus and Neptune's Triton. If we, as space artists, cannot visit the places we paint—as did the artists of the Hudson River School who traveled with the pioneers who opened up the American West and regaled the public with dramatic canvases of Yellowstone and other wild areas—this is the next best thing!

Like my good friend Joel Hagen, who has written elsewhere in this book about his techniques for sketching in the field, I find sketching in areas on Earth that are analogous to alien landscapes to be invaluable. While he uses colored pencils on black paper, I prefer using pastels and a fine black pen for details on a neutral-colored pastel paper, such as brown or gray.

David A. Hardy, FBIS, FIAAA, illustrated his first book (for Patrick Moore) in 1954 at the age of 18. He has written and illustrated seven of his own books and has worked in TV, video, and movies. In addition to painting, he now works on a Mac. David is European vice president of the IAAA and recipient of its Lucien Rudaux Award. His website is www.astroart.org.

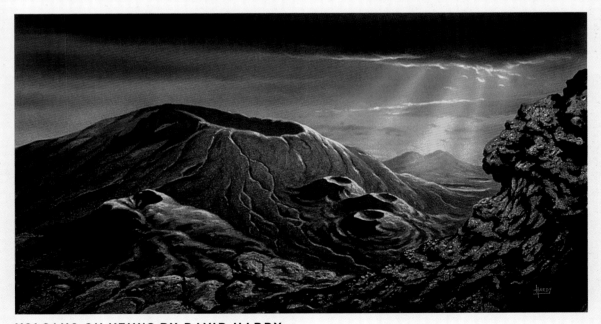

VOLCANO ON VENUS BY DAVID HARDY
Beams of sunlight break through the clouds, illuminating a Venusian volcano in this painting by David Hardy. (From *The Fires Within: Volcanoes on Earth and Other Planets,* Dragon's World, 1991)

MARS FROM DEIMOS

LEVEL: BEGINNER

Painting the planet Mars is great fun. Its dramatic, rusty surface and brilliant polar caps make for an impressive scene. The face of the red planet is covered by a wonderful calligraphy of lines, splotches, and shadowy shapes. Until the age of modern science, it was assumed that these dark areas were vegetation. It turns out that these dark regions are volcanic dust blown by seasonal winds, but everyone was fooled for a while.

Mars has two moons. The smallest moon is also the farthest from the planet. Tiny Deimos circles 14,500 miles (23,500 km) above the Martian landscape. Its sibling, Phobos, orbits at less than half that altitude. From Deimos, we would sometimes see Phobos between us and Mars. Deimos is a potato-shaped moon about ten miles across, little more than a large cosmic rock. Let's imagine what it would be like to stand on its surface and see the sights.

This photograph of Mars was taken by the Hubble Space Telescope. It shows the thumb-shaped dark marking called Syrtis Major. Notice the icy polar cap at the south pole of Mars. Visible in the north is a polar "hood" of mist from the ice cap at the north pole. The roundish light area at lower right is called Hellas and is the remnant of a giant impact crater. (Courtesy of the Space Telescope Science Institute)

Left and center: Two views of Mars's largest moon, Phobos, taken by Mars-orbiting spacecraft. Phobos is 17 miles across in its longest dimension. Right: Comparison of Phobos and Mars's smaller moon, Deimos. Both are irregularly shaped. (Photo credits from left to right: *Viking* spacecraft, NASA/JPL; NASA/JPL/Malin Space Science Systems; NASA/JPL/Malin Space Science Systems)

The Plan You will tip the axis of Mars so that the planet is dramatically tilted in the sky of Deimos. Remember that a globe is cut in half between top and bottom by the equator, and between left and right hemispheres by the polar axis (this is the line the planet spins around). The bright polar caps lie at the ends of the polar axis. Sketch in the dark areas on the planet, and put Phobos in front of Mars to the right of the polar axis. Mars will be a crescent, so Phobos will float above the nighttime dark area of the planet.

Step 01 Paint a black sky on a vertical canvas, then cover the top three-quarters of your canvas and spray in some toothbrush stars (see step 1 of "The Earth from the Moon" on page 39).

Draw a circle about two-thirds the width of your canvas, right in the center but fairly close to the top. Your Mars will be a crescent, so draw a line through the center of the circle to show you where the poles will be. Angle it slightly toward the right (clockwise) so the crescent will tilt up toward the left. Use an ellipse template or carefully draw a crescent freehand, ending it at the poles (see "Drawing Spheres" on page 15). Try several sizes if you want, making sure that the fullest part of the crescent is always right in the middle at the equator.

Step 02 Fill in the crescent with orange, using a mixture of two parts raw sienna, three parts burnt sienna, one part acra violet, and three parts white. Add dioxazine purple and a little black to the same color and lay on a much darker night side. Keep this color light enough to show some detail. Add a bit more purple and black toward the crescent. Fun fact: The darkest part of a ball is always right up against the illuminated side.

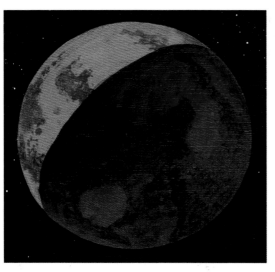

Step 03 Use the reference image of Mars on page 56 to guide you as you put dark areas on the Martian globe. On the daylight side, the dark areas will be a mix of burnt and raw sienna. On the shadow side, the dark areas will need to be nearly black, with just a hint of burnt sienna and purple. Use a damp kitchen sponge and a detail brush for your textures. Using clear water, you can "paint" areas to be darkened before using your sponge. This helps soften the sponge textures.

In the center of your globe, place the thumb-shaped Syrtis Major. Sketched by the fifteenth century astronomer Christian Huygens, this dark region was one of the very first things recognized on another planet through a telescope. It's one of Mars's most recognizable formations.

Step 04 Soften the terminator by brushing on a mixture of raw sienna, burnt sienna, and purple. Tap it out with your finger. You want a fairly soft transition between light and dark, but you also want to retain nice points at the poles between shadow and light.

Step 05 Add a highlight to the sunlit edge of the planet.

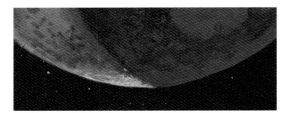

Step 06 The polar caps of Mars are dramatic, bright areas of frozen water and carbon dioxide (dry ice). To paint them, lay down a mix of ultramarine blue and white, darkening the night side by adding a little purple to the blue and white (*top*). On the sunlit side, brush on a layer of pure white (*bottom*).

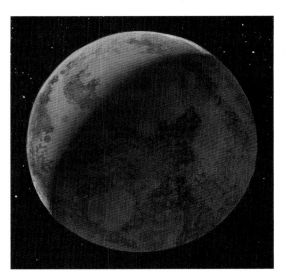

Step 07 To complete our Mars, brush a thin wash of black and purple over the night side using a large, soft round brush or a sponge. Tap it out with a soft sponge or your finger so that it forms a dark mist over the detail you already have.

Step 08 Put the inner moon, Phobos, in front of the night side of Mars. Use a mix of black and white for the sunlit crescent. Although Phobos has a very rugged shape, its crescent must point in the same direction as the crescent of Mars itself. Define the night side with black. Use the reference shots of Phobos on page 56 to get ideas for painting the details.

Step 09 Block in your landscape using a mixture of black and white. Keep it very neutral in color. Choose a few areas to sponge on some darker rock shadows.

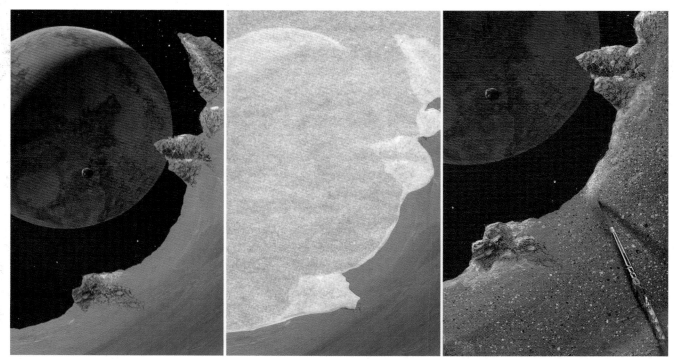

Step 10 Add sponge highlights to your rocks (*left*). Then, covering the sky with a tracing paper mask (*center*), texture the rest of your painting with your toothbrush-gravel technique (see step 10 of "The Earth from the Moon" on page 43). Add a highlight wash to your horizon (*right*).

Put in some crater shadows and highlights, making sure they are consistent with the rest of your painting. The horizon is irregular, and the craters follow the lay of the land, no matter how steep the surfaces. Add a few bright gray dots in your shadowed washes, and some dark dots in your highlighted regions to give it that random texture.

Your beautiful Deimos landscape is finished. Who says Deimos doesn't have atmosphere!

Opposite: **MARS FROM DEIMOS BY MICHAEL CARROLL**

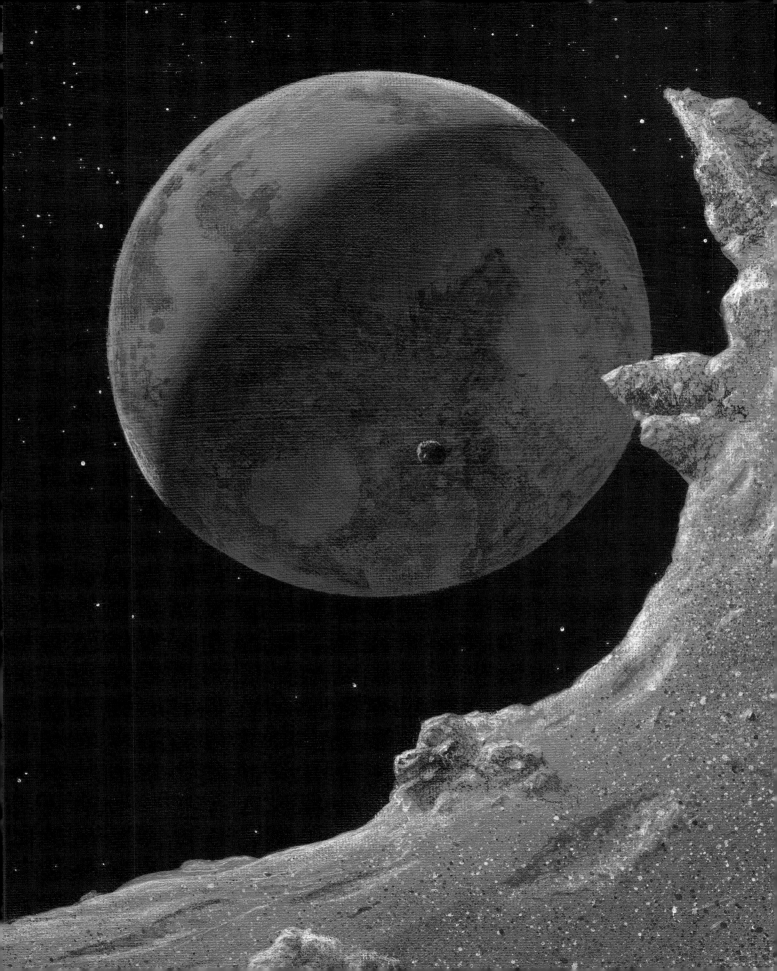

ANCIENT MARS

LEVEL: BEGINNER

Mars has always been an enigma that has fascinated humans. With the advent of spacecraft, our early visions of Martians and canals gave way to a desert world, bitterly cold and desolate. Daytime temperatures in the hottest "tropics" of Mars scarcely reach the freezing point of water. Nighttime temperatures are cold enough to turn the poisonous carbon dioxide atmosphere into dry ice. The air is as thin as Earth's atmosphere at an altitude of 100,000 feet. It seems a forbidding, dead world.

But as spacecraft studied Mars more closely, over time we began to understand the planet's rich history. Scientists still debate what Mars was like early in its life. Evidence from orbit and from surface explorers like the Mars rovers and *Viking* landers has shown that at one time Mars was a more Earth-like world than it is today. It was much warmer, and its atmosphere was denser. Mars may have had lakes or even oceans washing across its landscape. The question of life, then or now, is still an open one.

But something happened to the red planet. Most of its atmosphere was lost to space, and temperatures plummeted. There was probably a time when Martian water was locked up as glaciers and snow, as some still is today at Mars's north and south poles.

We are about to visit Mars in the past. Here, Mars has lost some of the air and heat from its earliest epoch and is on its way to becoming the cold desert world we see today. Still, your sky will be more blue than the thin tan haze that modern spacecraft have shown us. Any Earth-like lakes and oceans are gone. They've given way to ice. Rather than the barren desert mountains of today, snow clings to the mountainous rims of great impact craters. This painting gives us a great lesson in painting ice and snow. Let's explore!

The Plan You'll start with a vertical canvas. The sky will stretch from the top to about one-third of the way down, grading from a nice gray-blue to a raw sienna. Rugged crater rims have degraded into mountains capped with snow.

Step 01 The color scheme for this sky is a hint of phthalo blue in the upper sky, mixed with equal parts ultramarine blue and burnt sienna, giving you a fairly neutral sky. As you work your way toward the horizon, the gray-blue will lighten. Add white and raw sienna to the base colors. Use X strokes to mix your paint on the canvas, then smooth it out using side-to-side blending strokes.

Step 02 Put a crescent Mars moon up in the sky. Mars has weird moons, so here's how to do it. First, make sure it is pointing to the right, because that is where our sunlight will be coming from. Mars's moons, Phobos and Deimos, are rough, irregular moons. Pattern your moon after one of the photos on page 56, and paint it in using thin, white paint and a detail brush. Let the sky color be your shadows. You can even put in both moons, if you want to be really adventurous.

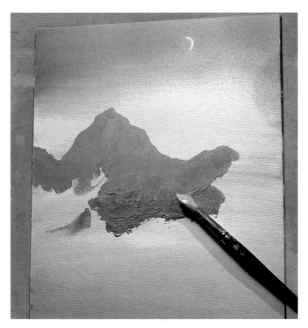

Step 03 First, block in a roughly pyramid-shaped mountain with smaller ones on either side, using approximately three parts white, two parts burnt sienna, and one part black. Your goal is to make a shade of warm gray that is dark enough to show the highlights and light enough to show the shadows. Your composition will be stronger if you don't plop your mountain right in the middle.

Keep the random shapes of nature in mind. Every bump, every peak should be different from the last. Bring the color down far enough that about one-quarter of the canvas is left at the bottom. Let this base coat dry (you can use a hair dryer).

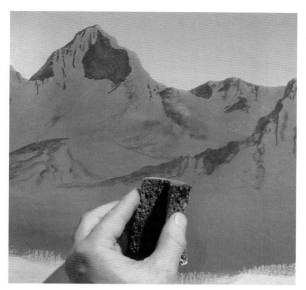

Step 04 Now, put in the shadows. Use the same colors, but less white and a touch more black. Paint in a large, teardrop-shaped shadow near the sunlit (right) side of the mountain and shadows defining the edges opposite the sun (left side). Use a small brush or sponge to add texture here and there, but don't overdue it. Snow will be covering some of those details! Refer to step 6 of "A Landscape on Mercury" on page 46 to make your shadows look like cracks in the mountains.

Beneath the craggy mountain shadows, put in some gentle hills. These are rounded versions of the hills and cliffs we painted on Mercury and Venus. Notice that the shadows are soft, not hard edged. Remember: To make valleys, have the shadows fade out toward the sunlit side (and highlights fade out the opposite way).

Now, sponge on some highlights, using a detail brush to blur the edges. The highlights should be dim.

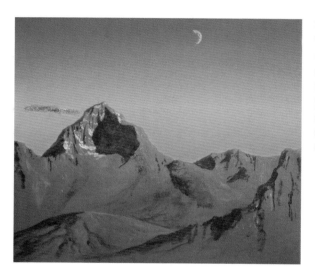

Step 05 After your highlights and shadows are in, it's time for the magic! Adding snow to your peaks will give them a spectacular dimension. Start with the central peak. That dark teardrop shape defines a bowl-shaped depression in the face of our mountain, but it needs help from our snow. Imagine that you are painting a smiley face across your mountain, with half in shadow and half in sunlight. Use pure white to paint in the snow on the sunlit side, making sure its form exactly matches the edge of the snow in the shadows.

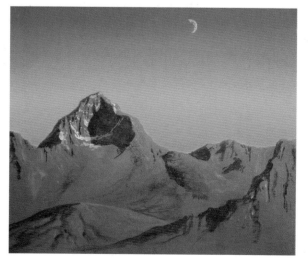

Step 06 Add some ultramarine blue to the snow for the shadow side to make it considerably darker than the white snow. Make sure that you create sweeping forms that lead from sun to shadow.

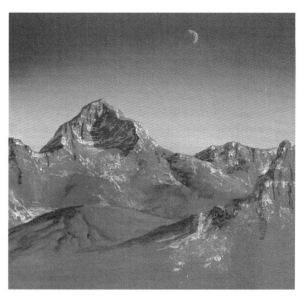

Step 07 Continue adding snow to your landscape. Where the sunlit snow meets the shadows, there should be a few wide areas and a few narrow ones. Leave a lot of mountain showing (don't overdo the snow), and keep the shape of your mountain in mind. The lines of snow should dribble down the slopes to give the viewer a sense of form—steep here, shallow there. It's your mountain. You define the shape.

Step 08 After snow has finished falling on your Martian peaks, put in a snowfield in the foreground. Use a wide brush and lay down a layer of ultramarine blue and burnt sienna mixed with white. Keep it fairly neutral, but bluish.

Step 09 When your blue-gray base is dry, take a wash of white paint and spread it over the darker foreground. Don't be afraid if it beads and streaks; this will add snowy texture to the painting. As this wash is drying, hit it with a light spray of white paint from your toothbrush, using a mask of tracing paper to protect your background.

Step 10 When the white wash is dry, add highlights with a detail brush and thin white paint to define slopes and hollows. Be creative with your hills and valleys!

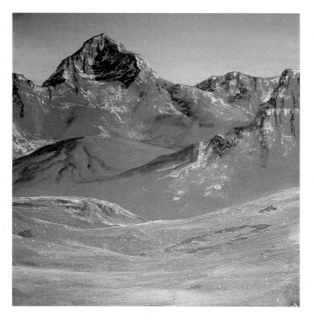

Step 11 Now, put in a crater rim sticking out of the snow. Use the same rules as you learned in step 7 of "A Landscape on Mercury" on page 47, but imagine that the bottom of your crater is now filled with the snow you just put down. The crater rim should look like a ring of rough stone. Since you're still on Mars, use the same mix of one part raw sienna, one part burnt sienna, and white or black as needed for highlights and shadows. Each bump should cast an ultramarine blue shadow to the left across the snow.

Finally, put in a few craters on the distant hills at the base of your mountain. Let the ellipse of each crater point the way down the hill.

Your landscape is complete. If you were successful, people will shiver every time they look at it!

Opposite: ***ANCIENT MARS* BY MICHAEL CARROLL**

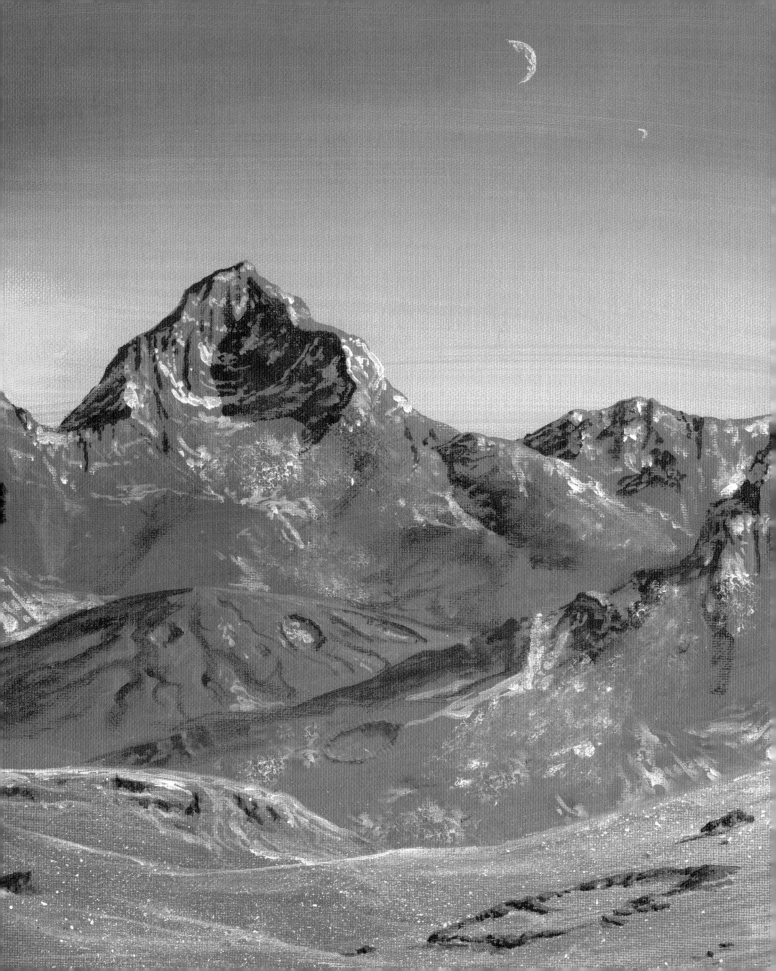

GUEST ARTIST
ASTRONOMICAL ART:
THE PLEIN AIR CHALLENGE BY WILLIAM K. HARTMANN

Plein air painting refers to the practice, developed especially by the French impressionists, of painting outdoors from natural landscapes. But plein air space art? Isn't that an oxymoron? I'd argue that it's a valuable practice for the space artist. If you continue painting your regoliths and rocks in the studio, they come to be not the real things, but only your own versions of those things. Painting from reality keeps you honest. You maintain the struggle to paint the way real sunlight interacts with real landscapes.

Part of the plein air challenge, at least for me, is "letting go." As Monet and others discovered, light and weather can change so fast that you have to abandon the careful, intellectual approach. Get into a different mind space, and go with your instincts. You'll quickly learn how good a painter you are! The more facility you have acquired, the more you can trust yourself to sketch out the general shapes (I do it with chalk) and then plow into paint without too much analysis. I find that experimenting with the palette knife, mixing some local soil into the pigment, or spattering different colors with a toothbrush are all ways to bring texture and personality into the picture—and to be spontaneous!

Working in that mode, I often have the strange and wonderful experience of getting completely lost in the painting, and an hour or two later coming back out of the painting. This process of "coming back out" feels to me like a transition between hemispheres of the brain: leaving the holistic visual part and looking afresh with the critical part. This is the time to look at the reflection of the painting in the car window (I'm too lazy to carry a mirror) and find out for the first time what you've really done!

Each attempt to follow this path teaches a new lesson. Some may not be as good as others, but the trick is to learn from each one. Lean your painting against the wall until it speaks up and tells you what's wrong with it. Then go back out under the sun and do another one that's better.

Bill Hartmann travels with a bag of acrylic paints and small boards, for quick sketches in exotic locales. Here, during a field trip at a scientific conference in Iceland, he paints on Surtsey Island, created in the 1960s by a volcanic eruption off the coast of Iceland.

William K. Hartmann, a fellow of the International Association of Astronomical Artists (IAAA), is known internationally as a planetary scientist, writer, and astronomical painter. He has received the IAAA's Lucien Rudaux Award, was awarded the American Astronomical Society's first (1998) Carl Sagan Medal, and has an asteroid named after him.

EXTRASOLAR PLANETSCAPE BY WILLIAM K. HARTMANN

An extrasolar planet, visible in the sky of an Earth-like satellite, was painted among the volcanic squeeze-ups of the Ka'u Desert in Hawaii Volcanoes National Park.

FIRST ON MARS BY WILLIAM K. HARTMANN

This scene was painted *en plein air* in the Pinacate volcanic region of northwest Mexico—a Mars-like region of lavas, cinder cones, and dunes.

MODERN MARS

LEVEL: BEGINNER

Despite its apparent desolation, Mars is actually the most Earth-like of all the planets. Some orbital views of Mars are a spitting image of space shuttle snapshots of Monument Valley or Canyonlands in the southwestern region of the United States. Many other places on Mars resemble subarctic or arctic regions, such as the tundra of Siberia or Alaska. Painting a Mars landscape—at least of some places on Mars—is a lot like painting an earthly desert. Let's give it a try!

The Plan Do a sketch the same size as your canvas. Choose a spot slightly to one side or the other for your largest mesa. You'll balance the mesa on the left with Mars's two moons in the sky at right. Mesas in the distance will provide scale, and a dry, sweeping arroyo will lead the viewer into the painting. For good measure, throw in a couple of eroded craters, just like the Mars rovers have seen. Now, it's off to the paint box.

Step 01 Begin with the sky, which will come down about one-third of the way on your horizontal canvas. Roughly at the level where you'll put in your horizon, run a bead of white paint. Above that, lay down a line of raw sienna, interspersing it with some ultramarine or cobalt blue. At the top, add more blue and a little burnt sienna with a touch of white to keep it light (*top*). Use X strokes to work the paint in, adding water as needed (*center*). A soft, flat brush will give you a smooth effect as you stroke from one side of the canvas to the other, making sure not to stop in the middle (*bottom*). Remember: Brush all the way beyond the edges of the canvas!

Step 02 Mixing some raw sienna, white, a touch of blue, and enough burnt sienna to give it a reddish hue, lay down an undulating horizon with some subtle hills. Let a few distant buttes and mesas stick up here and there (see "Mesas" on page 19). Keep them small. Remember that one area of your horizon will be covered by the foreground mesa, so you don't need to add detail all the way across the canvas.

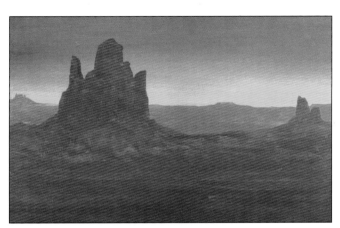

Step 03 Add a little more raw and burnt sienna to your background horizon color and begin to lay in your foreground. As you get closer to the bottom of your canvas, keep adding color, along with just a touch of black, to end with a rich, medium brown.

It's time to learn how to paint a mesa. Lay down a rich brown mesa shape, using the same color that you have about halfway down your foreground. Tap out the bottom of the mesa shape with your finger so that it blends in with the ground color that's already there.

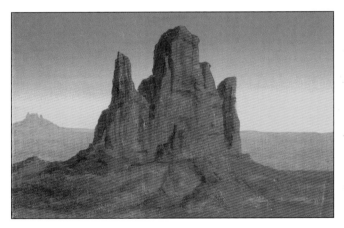

Step 04 Using a mix of burnt sienna, raw sienna, and black, put in hard-edged shadows on the cap-rock section of your mesa (the "top" part of the top-hat shape). The shadows will be thickest away from the sun side of the canvas, breaking up and becoming thinner as they reach toward the middle. The shadows should completely cover the edge of the rock next to the sky on the shadowed side. Put fainter shadows on the distant mesas, making the shadow color more similar to the base color. The cap-rock cliff sticks out of a pile of rubble (the talus slope). Shadows on the talus slope will be softer.

Step 05 Next to the shadows, lay in highlights with a mix of raw sienna and white. In each case, put down a line of highlight (*left*), then smudge the bottom of the line to make it look softer (*right*). As the highlights spread toward the center of the mesa, they will break up just as the shadows did.

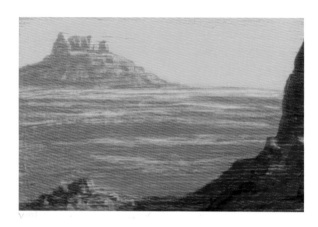

Step 06 Now, use thinner paint to brush on highlights in the background. Tap out the color with your finger in areas that you want to be faint. Remember to keep the highlights fairly horizontal on the flat ground, and bring the detail lines closer together as they reach the horizon.

THE MARS ROVERS

In early 2003, NASA landed two rovers on the surface of Mars. *Spirit* and *Opportunity* were designed to explore the surface of Mars for at least three months. Scientists hoped they would travel at least one-third of a mile. As of this writing, the plucky rovers have each traveled over four miles, a record for robotic driving! They have shown us sand dunes, mountains, craters, volcanic rocks, what may be an ancient lakeshore, sunsets, and dust devils. We can only imagine what vistas the little robots will send home as they continue their journeys. Other rovers—even more advanced than *Spirit* and *Opportunity*—are slated for launch in the near future.

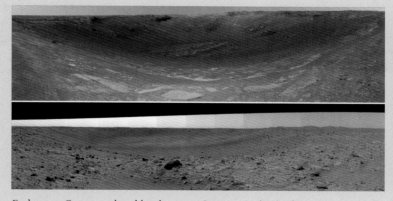

Endurance Crater, explored by the rover *Opportunity* (*top*). The crater Bonneville, imaged by *Spirit* (*bottom*). (Courtesy NASA/JPL/*MER* Team)

Craters in the soft Martian sand, glimpsed by *Opportunity*. (Courtesy NASA/JPL/*MER* Team)

Step 07 Lightly brush in shadows and highlights across the Martian desert floor, using thin paint. Keep it wet and tap it out to soften the edges. For these shadows, add a bit of dioxazine purple to your burnt sienna, raw sienna, and black. Experiment until you get a little rich color in your shadows. This gives your painting added life. You can work some purple and alizarin crimson into other deep shadows, too.

Don't forget to work in some craters here and there. The kind you would expect to see in this landscape will have soft edges. For reference, see "The Mars Rovers" on the previous page.

Step 08 It's time to add our magical toothbrush gravel. For reference, see step 10 of our moon landscape on page 43 or step 9 of the Venusian volcano painting on page 52. Cut out a tracing paper mask to go around any talus slope in the foreground. This will keep your gravel where you want it to be.

Spray dark gravel over the shadowed half of your talus slope, letting some fall toward the sunlit side. Before this dries, spray highlight gravel on the sunny side, letting some intermingle with the dark gravel in the center. Add a few random boulders here and there to complete the effect.

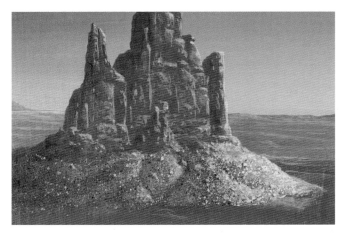

Step 09 After your gravel dries, brush a faint wash over the shadow side to make the farthest edge dark. Brighten the sunlit side in the same way. Add small shadows to the larger blobs of highlight paint and a few highlights to the larger blobs of dark gravel.

Mask the sky and distant horizon and sprinkle gravel across your flat landscape. Add gravel texture to the shadows and sunlit areas of your craters and arroyo. Let these sprinkles mingle with the gravel at the base of your mesa.

Using a white wash, place two crescent moons in the sky, making sure they point in the direction of the sun.

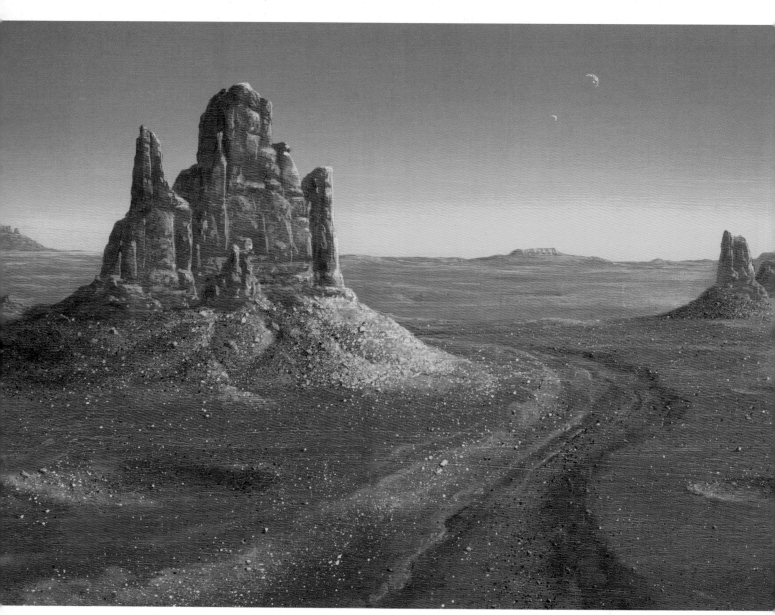

MODERN MARS BY MICHAEL CARROLL

You now have a finished Martian masterpiece that even Ray Bradbury would envy!

GUEST ARTIST
PAINTING THROUGH A TELESCOPE BY DON DAVIS

Looking at the Moon, Venus, Mars, Jupiter, and Saturn through a telescope is a good way to imagine what a planet looks like up close. Getting a visual impression is useful even if the telescope is not a large one. It will give you a beginning step from which to visualize the planets you wish to paint. In the case of the Moon, a modest magnification will allow you to see the entire cratered world; the planets will require all the aperture and magnification you can muster to see them as small round objects.

The Moon appears gray at first, but careful scrutiny through a telescope, particularly near full moon, will reward the viewer with bluer dark lava flows and tan patches here and there on the dark lava "seas," or "maria."

Studying the Moon will help you to depict planets. Other worlds that are airless like the Moon are also likely to be covered by craters. Studying photographs of the Moon and looking through a telescope are helpful for getting a feel for the distribution of craters across planets that have them. For example, on the Moon, roughly ten times more 1km craters exist than 10km craters.

When the Moon is full, the brightness and color differences are all that can be seen. The difference between light and dark parts of the Moon are miniscule compared to the difference between the sunlit parts and the comparative blackness of surrounding space. As the Moon changes its phases, seeing it through a small telescope or even good binoculars will show these differences more clearly.

You can see similar brightness differences on Mars, a Moon-like but unique desert world with an intriguing past. Again the contrast between the dark regions and the brighter ones is only a tiny fraction of the brightness between the bright sunlit world and the space beyond. It is important to appreciate this because photos you might use for reference have been generally heightened in contrast, sometimes enough so the darker parts of a planet appear as black as space. This is done to bring out faint detail. The bright regions of Mars appear a light ripe-apricot color, with the darker, rockier regions a darker gray to gray-brown. Through most refractor telescopes the dark, regions of Mars look turquoise green against a lighter yellow ochre.

Behind artist Don Davis is his painting of the *Surveyor* spacecraft on the Moon.

Don Davis was mentored by the "old master" of space art, Chesley Bonestell. In the late 1970s he worked on the widely seen PBS show *Cosmos*, hosted by Carl Sagan, and his work appears in Sagan's books *Comet* and *Pale Blue Dot*, as well as on the cover of his Pulitzer Prize–winning book *The Dragons of Eden*. Davis started out working in oils and acrylics, but computer graphics is now his primary medium. He makes his living creating animations for projection in planetarium domes.

IO BY DON DAVIS

Jupiter's moon Io floats to the right of the king of worlds. Jupiter itself dwarfs Io in size, but if we flew past the little moon at close range, it would appear larger than its parent planet. Note the umbrella-like volcanoes erupting from Io.

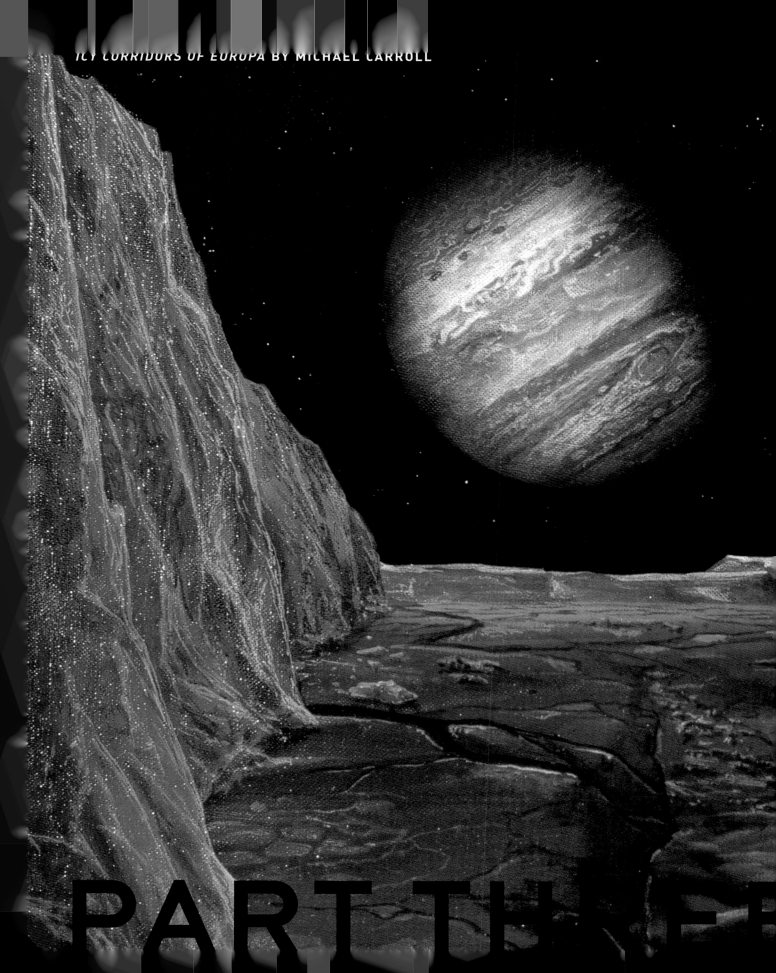

PART THREE

THE GAS GIANTS

Outside of the orbit of Mars, things get pretty bizarre. The giant planets reside in this cold, dark realm. They are called gas giants, because their visible surfaces are entirely clouds of gases. In fact, these planets have no solid surface at all.

The gas giants are much "softer" in appearance than the Earth-like planets. While the rocky inner worlds are hard edged (like a soccer ball), the gaseous worlds have a foggy, soft limb (more like a tennis ball). Jupiter, the largest planet, is striped with colorful belts. Golden Saturn is the only planet with visible rings. Uranus is a featureless pale green disc. It is a subtle, monochromatic version of the other gas giants, so we'll skip over it and travel to the next stop beyond, Neptune, a rich blue ball with deep azure bands, crowned by wisps of icy white clouds.

The moons of these planets are ice worlds and provide fine platforms from which to paint. Let's venture to the outer realm of the gas giants.

A VIEW FROM JUPITER'S MOON IO

LEVEL: INTERMEDIATE

Jupiter is the big kahuna, the chief bwana, the big cheese of the solar system. It's probably important that we learn to paint it! Over a thousand Earths would fit inside of Jupiter. Like Saturn, Uranus, and Neptune, Jupiter is a weather world. There is no solid surface for a Jupiter probe to land on, only deeper and denser clouds. These clouds are stretched into horizontal bands by the fast rotation of the planet (despite its grand size, Jupiter spins completely around in about ten hours!). The bands of Jupiter, called belts and zones, are a symphony of earth tones. Over these bands of color, white and tan clouds swirl and mix in a serpentine dance across the planet's face. When we paint it, we'll put on our paint the same way Jupiter wears its clouds, in layers from dark to light.

The gas giants hold large families of moons. Jupiter's moon Io is one of the strangest worlds ever seen. It is literally covered with volcanoes, lava, sulfur flows, and geyser-like jets that thunder over 300 miles (500 km) into the airless sky. Io's violent nature is forged by the push and pull of mighty Jupiter's gravity on one side and the gravity of three other moons on the other side. Europa, Callisto, and planet-sized Ganymede all pull on Io so strongly that its surface rises and falls 150 feet each day. All this moving and shaking makes heat build inside, and that heat comes out as dramatic volcanoes. In this painting, we'll be perched on the edge of one of these volcanic craters, looking out at Jupiter in the airless sky.

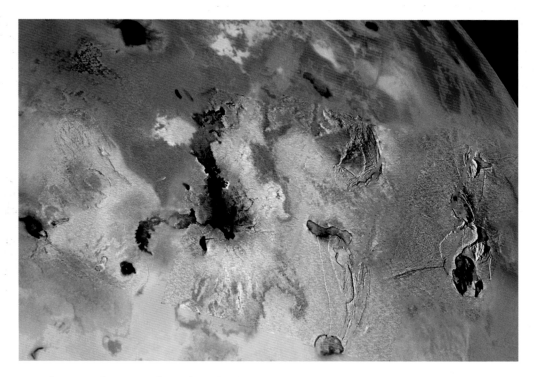

Every feature in this NASA photo of Io taken by the *Galileo* orbiter is volcanic in nature. (Photo courtesy NASA/JPL/*Galileo* mission)

You'll be basing your Ionian landscape on a nifty volcanic crater in Death Valley, California. The crater is called Ubehebe, a Shoshone word meaning "basket." I made the on-site sketch (*right*) under slightly different lighting conditions. (Plein air sketches help me to understand the forms, textures, and shadows in land areas like this spectacular crater.) (Photo by author)

A LITTLE MATH: BECAUSE SIZE MATTERS IN SPACE ART!

When painting a view of a planet, the first step is to choose a size for the planet. Here we'll be doing a landscape of Jupiter's moon Io, which is nerve-wrackingly close to mighty Jupiter.

We can use simple math to figure out roughly how big Jupiter should be in our Ionian sky. It works like this: Multiply the diameter of the object at which you are looking by 57.3 (this number is always the same). Divide that number by the distance to the object and—*voila!*—you have a number that tells us how many degrees across the sky the object should appear.

Using the numbers above, multiply Jupiter's diameter (143,000 km or 89,000 miles) by 57.3. Then divide that number by Jupiter's distance from Io (422,000 km or 220,000 miles). The number we get, 19.5, tells us the number of degrees in the sky Jupiter appears. Since the human field of vision is approximately 40 degrees, Jupiter would fill up about half the sky. To put this in perspective, the Moon in our sky appears about half a degree across. From Io, Jupiter would appear to take up the space of thirty-nine of our full moons!

The Plan As we just noted, Jupiter is about 19 degrees across in the sky of Io. If our canvas is a typical landscape's 40-degree field of view, then Jupiter will take up about half that. As artists, we may want to change the size of Jupiter a little so that our composition is just right, but it's good to be accurate where we can.

First we'll sketch a circle roughly the correct size. For this painting, we want to see the entire planet, although we could have it peeking over the horizon. We'll keep our Jupiter in the upper third of our painting, anticipating a horizon a little below the halfway mark on our canvas, and sketch in the belts and zones (see "Fisheye Perspective" on the next page).

FISHEYE PERSPECTIVE

In many NASA spacecraft photos, the belts and zones of Jupiter are parallel to each other. This is because the photos are taken from a great distance through a telescopic camera. It is as if we are standing in a parking lot, looking through binoculars at an oil drum on the other side. The top, bottom, and ridges of the drum look parallel. But if we cross the parking lot and have a closer look, our closer perspective warps the lines of the barrel so that they bend toward each "pole" (at the top and bottom). The same is true when looking at Jupiter from a close distance, like from Io. Jupiter's belts will bend toward the poles because of our close "fisheye" perspective.

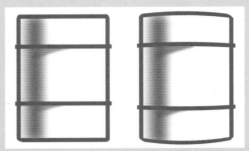

When seen close up, the ridges of an oil drum appear to curve toward the top and bottom. Jupiter's belts also curve toward the poles when viewed from a close distance.

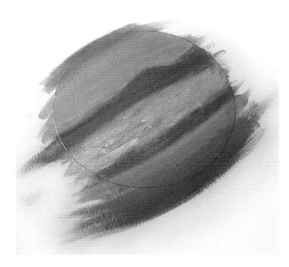

Step 01 After sketching in the belts and zones, lay in the darkest belts with burnt sienna and just a hint of ultramarine blue to darken it. The equatorial belt is more yellow, so it gets a bit more raw sienna and white. Above and below the dark belts, lay down a mix of burnt sienna, white, and enough blue to give it a true blue tint. Use tiny X strokes to make sure the edge of each stripe fades softly into the next. You want each belt to retain its color, so don't mix too far. Don't worry about neatness; the paint should extend beyond the circle.

Don't forget to leave a bulge if you want to see the Great Red Spot (note that the red spot is not always visible, since the planet spins around once every ten hours). For this view, put it in the upper part of Jupiter. If your viewer is standing on the southern hemisphere of Io, Jupiter will appear upside down. Use more burnt sienna, ultramarine blue, and raw sienna on the darker poles. The north pole has more raw sienna, while the south is bluer.

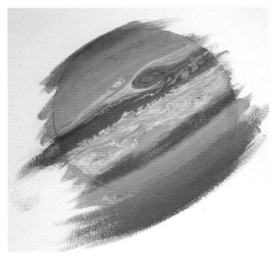

Step 02 Now comes the fun part: detail! Referring to the photo of Jupiter on page 23, put in colorful underpainting shapes. These bands of color will define the hues under the cloud tops. Once these colors are down, overlay them with white and tan cloud tops, always referring to nature (in this case, your photo references). As you put cloud-top color down, make one side of each cloud sharp and have the other fade away. Keep the paint thin and tap it out with your finger to fade it away at one edge.

In the north and south, put in those oval storms, using the crater perspective rules described in "Craters" on page 21. Remember that the long axis of each oval tends to shift to become parallel to the nearest edge of the planet.

Step 03 Now, fill in the black sky, using the same wrist action that you did in step 5 of "The Earth from the Moon" on page 41.

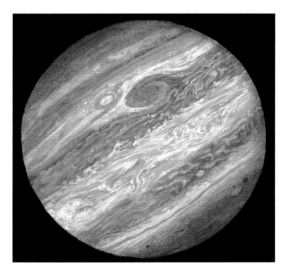

Step 04 After Jupiter's edges are nice and neat, rub some soft tan and light blue color over the belts to soften the clouds further, as needed. Keep looking at the reference photo! Add a thin wash of blue to the top, bottom, and sunlit limb (*top*). Then wash a dark layer across the shadowed side (*bottom*). Make sure your terminator has a soft edge.

Mask the planet with tracing paper and finish the sky with a toothbrush starfield (see step 1 of "The Earth from the Moon" on page 39).

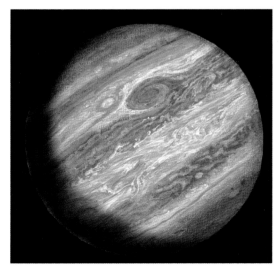

Step 05 Block in the basic colors of the crater using raw and burnt sienna with a bit of gray (white and black) in the right areas.

Block in the branching shadows on your crater. The darkest part of the crater will be on the same side as the sunlit side of Jupiter (on the right side), fading out as the sun takes over on the left wall of your volcanic bowl.

Add highlights. These will be tricky, as you want them to look like ravines rather than ridges. To achieve this effect, you must put each highlight adjacent to the shadow *on the left edge* of the shadow. If you get mixed up, the effect will be ruined.

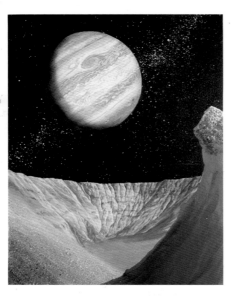

Step 06 You want your crater to surround you, so put steep slopes on either side. These will dramatically bracket the scene. Drop in some gravel on the sunlit side, using the technique in step 10 of "The Earth from the Moon" on page 43. Cap the shadowed slope with a sponged rock and cover your slope with gravel.

Step 07 To complete your painting, you have to sell the viewer on the idea that this is not just any crater, it's a *volcanic* one. Some geothermal goo in the bottom ought to do the trick. Start with equal parts of yellow oxide and raw sienna. Make a puddle at the bottom and add some radial fractures and a few highlights around it. Your Ionian crater is now complete.

Opposite: **INSIDE A VOLCANIC CALDERA ON IO** **BY MICHAEL CARROLL**

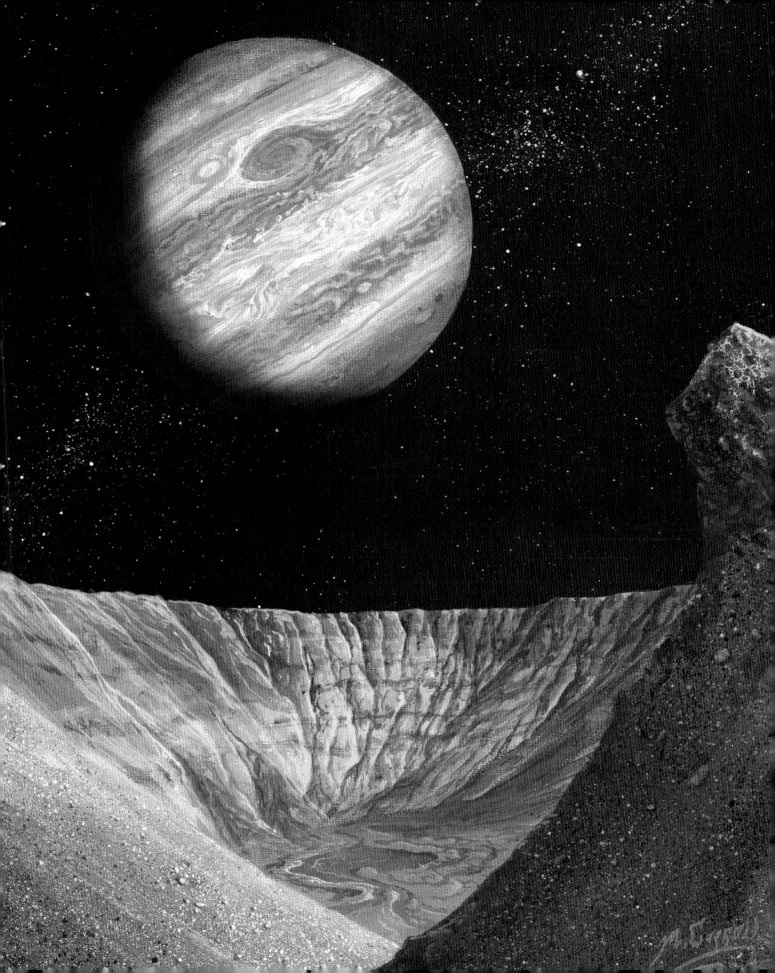

A JUPITER CLOUDSCAPE

LEVEL: INTERMEDIATE TO ADVANCED

The massive clouds of Jupiter are nearly impossible for the Earthling mind to comprehend. Storms the size of the African continent come and go in months. That would be a really long time for a storm to hang around on Earth, but an even larger storm has been raging on Jupiter for centuries. Called the Great Red Spot, this enormous cyclone could handily swallow two and a half Earths. Lightning bolts strong enough to power a city for days course through its poisonous clouds. Towers of ammonia ice crystals boil up through decks of puffy water-ice clouds, pulled into chevrons and banners by powerful winds. It is within this radical realm that we'll paint our next piece.

The Plan Your challenge is to create a cloudscape that the viewer will recognize as clouds, but one that seems very alien. Jupiter clouds seem to have well-defined areas and edges along the belts and zones. The oval storms are very alien looking, so you'll throw a few of those in. Earth thunderstorms flatten out into what meteorologists call "anvils," and you'll use some of these flat shapes for your cloudscape, too. Although most Jupiter storms are so large they would be hard to see from your viewpoint, you'll exaggerate the forms so they look like the Jupiter storms in photos. You're using your artistic license now!

Step 01 At the horizon, lay on layers of raw sienna and white, working in ultramarine blue as you move upward. Toward the top of the canvas, drop in some dioxazine purple and a hint of burnt sienna for an especially dark sky. Leave an area on the left for your towering cloud.

Step 02 The first clouds you paint will be within the raw sienna portion of your sky. These will define your cloudy horizon. Use a mix of equal parts raw sienna, burnt sienna, ultramarine blue, and burnt umber. More distant clouds will have more blue in them. Using your detail brush, paint in details of the platelike clouds. Tap out each line with your finger to give it that soft feeling. These lines will define the shape of your clouds. Put highlights—a mix of white and raw sienna—on top, but use them sparingly. Remember: You're looking up into the bottom of the cloud deck.

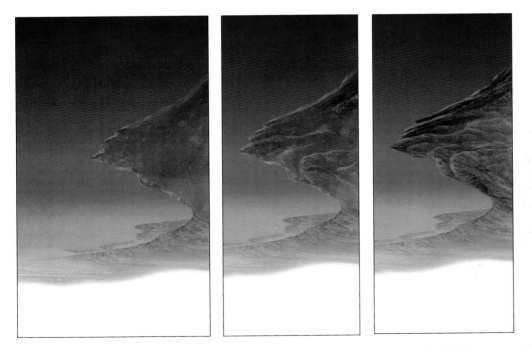

Step 03 To paint the large cloud on the right side of the painting, put down a base coat of raw and burnt sienna and ultramarine blue with enough white to make it a mid-tone (*left*). Next, add the highlights (*center*), and then the shadows (*right*). Be careful where you put your shadows in relation to the highlights, so that you end up with the effect of layers of clouds.

Step 04 Using a ratio of roughly three or four parts ultramarine blue, two parts burnt sienna, and one part white, lay down a band of color just below the horizon.

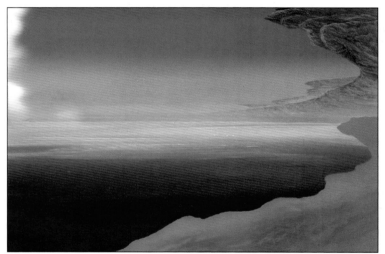

Step 05 It's time to put in a dramatic light stripe in the atmosphere. Yours will go to the lower right and lead the viewer into the painting, much as you did with your arroyo on modern Mars (page 70). Use a mix of mostly blue and white, cut with a bit of the burnt sienna to keep it grayish. Don't be afraid to let a little of the dark blue show through. Brush your strokes in the direction you want the viewer's eye to go.

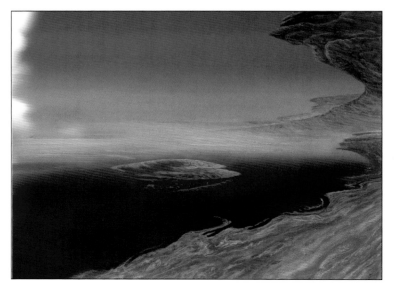

Step 06 Put in highlights and shadows at will, culminating in that distant anvil on the right. Work in some raw sienna on the border with the dark blue for drama. Using the same highlight tone, put in a few of those lens-shaped storms in the distance.

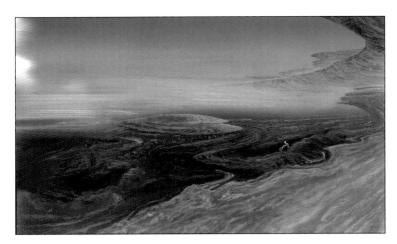

Step 07 Add cloud texture to the dark blue area using the same colors you've used for the lighter clouds. The clouds should swirl and mix, fading as they get to the warm horizon.

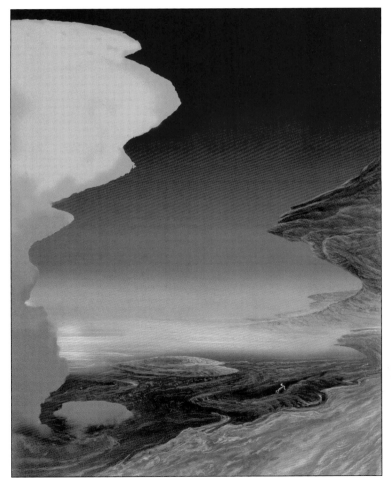

Step 08 Your painting will be bordered on the left by a towering cloud of ammonia. Like an earthly sunset, this cloudy one will fade and become richer in color toward its base. Start with a base coat of raw and burnt sienna, adding a little ultramarine blue toward the bottom.

Step 09 Work in shadows (*left*) and highlights (*right*) in the same way you defined bumps and valleys on rocks and cliffs in earlier paintings. These "cloud cliffs" just need to be softer!

Step 10 After detailing your clouds, add a few wisps in the clear sky above. These should parallel the contours of the larger cloud systems. Finally, put in the two nearest large moons, Io and Europa, using a wash of white. Remember to keep the sunlit side crisp, while the terminator fades out into the sky color. Io is closest and is distinctly orange, so put a wash of reds and yellows over your crescent after the white has dried. Leave Europa a pristine white. You now have a spectacular, alien cloudscape that Jove himself would be proud of!

Opposite: **JUPITER CLOUDSCAPE BY MICHAEL CARROLL**

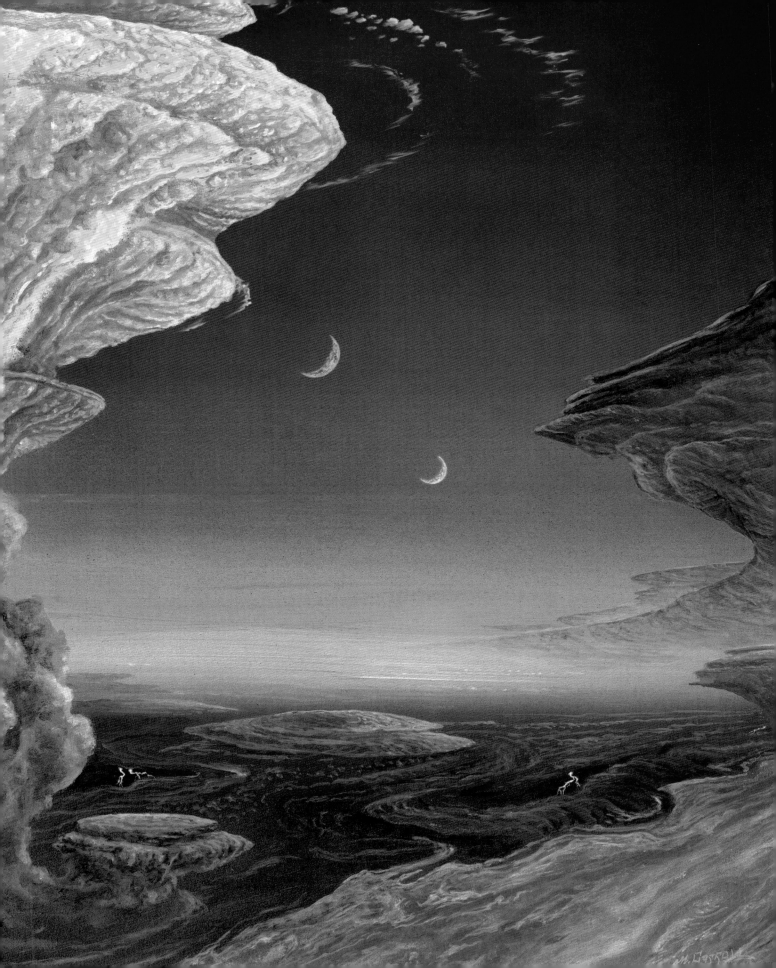

GUEST ARTIST
BRILLIANT COLOR IN SPACE ART BY KIM POOR

Color is the subject of much debate. I believe that different people experience color differently. Speaking as an artist, for artists, I think we experience color on a deeper level, perhaps more intensely than other, more analytical types. The blue of the sky in Tucson an hour after sunset is the perfect example: a color that seems to multiply itself the more it is viewed, and that affects me on an emotional, rather than purely optical, level. This dichotomy could be discussed at length to no resolution, but if you're a fan of color, let's examine how to render bright, saturated color in art.

First, I try to achieve colors without a lot of mixing. If you mix more than two colors, your color starts to turn into shades of mud. Second, I always use an airbrush. It's old-school at this point, but the airbrush uses the least amount of paint, can be used to build up intensity, and puts color down in small dots, which reflect light differently than brush strokes. This has never been adequately explained to me, but the proof is in the pudding. When light reflects off brush-strokes, it can rob the color of its intensity. Smooth paint retains a rich saturation of color.

Finally, I use the technique of glazing to paint textured, detailed, or shaded objects. This is an old technique employed by the Renaissance masters to achieve glowing skin tones. In acrylics or oils, there are certain colors, like alizarin crimson, phthalo blue, quinacridone red, and hansa yellow, that are transparent and can be mixed without the "mud" effect. Mixing an opaque paint with a sufficient amount of gloss medium will also usually produce a transparent or semitransparent paint. For this technique you will need to use transparent paints.

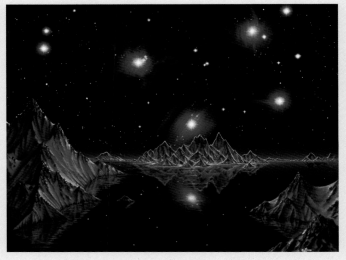

LADIES OF THE LAKE BY KIM POOR
The artist imagines a watery world near the Pleiades star cluster, also called the Seven Sisters. Each star of the "Sisters" is cocooned in a glowing cloud of blue gas. (© Kim Poor)

Underpaint your detailed object in black and white to give it a little boost in contrast. Spray on or apply your transparent paint as a wash to create a glaze. Recontrast if necessary, using an opaque color mix to match, but use caution: Recontrasting with too much opaque color will destroy the glaze effect. It's best to glaze, recontrast, and glaze again as many times as necessary. (Spot contrasting with more transparent color will have little effect.)

A final gloss varnish over the painting will bring out all the rest of the colors to their maximum intensity and tie the composition together into a coherent scene. Light reflects off the underpainting tinted by the glaze and gives a candy apple glow that can't be achieved digitally and is only marginally successful on motion picture film or video. It is a quality reserved for viewing in person. Check out a Rembrandt or a Maxfield Parrish original: To look at a reproduction is nice, but to see an original, wow!

Kim Poor has won numerous awards for his work, which has been seen in publications including *Omni* and *Sky & Telescope*, books such as Carl Sagan's *Comet*, and movies and TV shows including *Star Trek* and *Babylon 5*. He has become a confidant of most of the men who walked on the moon, and his company is the number one dealer for astronaut autographs and artifacts flown to the moon. He was the first copresident of the IAAA, which he cofounded.

Artist Kim Poor in his studio.

SATURN SEEN FROM IAPETUS

LEVEL: INTERMEDIATE

Iapetus is one of the most mysterious mini-worlds in our solar system. This small moon is only 912 miles (1,467 km) across, and its density tells us it is mostly water-ice. It's a two-faced moon, with one hemisphere as dark as asphalt and the other as bright as dirty snow. The dark area on Iapetus faces forward as the moon circles its parent planet, Saturn. Iapetus orbits above and below the plain of Saturn's rings, so that if you watched the planet in the Iapetus sky over the course of a day (seventy-nine Earth days), Saturn's rings would seem to bob back and forth like a spinning top.

Our best views of Iapetus come courtesy of the *Cassini* Saturn orbiter, which has snapped images from as close as 70,000 miles away. Snapshots show a cratered landscape with a strange ridge going around the equator. What would it be like to sit at the edge of the dark and light hemispheres? Let's imagine with our paintbrushes.

What makes this lesson more challenging than some of the earlier ones is the difficulty in painting Saturn itself. Study the photos of Saturn in "Saturn's Rings" on page 92 before sketching in your planet. Reviewing the techniques for painting snowy mountains in "Ancient Mars" on page 62 would also be helpful.

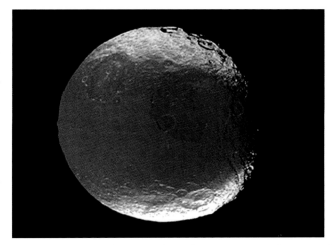

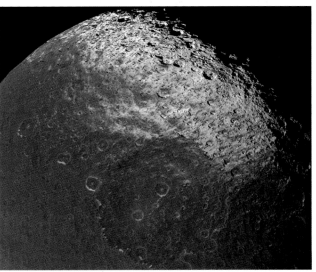

Two views of Iapetus, Saturn's two-faced moon, taken by the *Cassini* Saturn orbiter. Notice how dark material seems to drape over the light terrain in some places, while in others, bright objects appear to loom out of the dark stuff. (Courtesy NASA/JPL/*Cassini* mission)

As with all landscape painting, you must look to nature as your mentor. Iapetus has contrasting dark and light terrain, so it's helpful to find some earthly analogs. For your painting, you can use these photos from Death Valley, California, or some of your own reference. (Photos by author)

SATURN'S RINGS

Saturn is a complex study in light and shadow because of the rings that encircle it. Rings encircle all of the gas giants, though in every case but Saturn they are nearly invisible unless the Sun is behind them. Saturn's rings, swarms of bright, icy particles, are huge. From the inside to the outside edge, we could fit the United States end to end sixty-seven times over! The rings are beautiful. They appear to be concentric circles but are actually spirals of material, like grooves on an old LP. The tiny particles that make up the rings range in size from the consistency of cigarette smoke to ice boulders several meters (yards) across. Embedded within the rings lie many small moons the size of mountains (a few miles across).

In addition to Saturn going through the standard set of phases from crescent to full to new, its rings cast shadows across the face of the planet, and these shadows vary with the angle of the sun. To make matters more complicated, the rings cast soft light up onto the dark side, and the planet casts a shadow across the rings!

These views of the ringed giant Saturn were taken by the Hubble Space Telescope. Notice the structure of the rings and the subtle cloud bands. (Courtesy Hubble Heritage Project/Space Telescope Science Institute)

As Saturn turns on its axis, it bobs up and down in relation to the Sun. This causes the complex shadows of the rings to stretch across the face of the giant world. (Image by author)

Opposite top: As Saturn moves around the Sun, it goes through the same phases that our own moon does. From Iapetus we would see all of these phases. Notice, too, how the shadow of Saturn falls across the rings. (Image by author)

Opposite bottom: These photos, taken by the *Cassini* orbiter and the *Voyager 2* spacecraft, give us an idea of the beautiful complexity of Saturn's rings and their shadows. Notice in the bottom two photos how, as the ring shadows thicken toward the pole, the surface of the planet becomes more blue. Scientists do not yet know why this is. (Courtesy NASA/JPL/*Voyager* and *Cassini* missions)

The Plan Your beautiful Iapetus masterpiece will be vertical and will show both dark and light areas. You must choose your light direction carefully, as you want the light and dark to show off the changes in surface color. Your sunlight will be coming from the left side.

Step 01 Begin with a rich sky of dioxazine purple, ultramarine blue, and a bit of white toward the horizon. Iapetus has no atmosphere, so you're using your artistic license here! Spray stars across your heavens using a toothbrush (see step 1 of "The Earth from the Moon" on page 39), then sketch in your Saturn. This planet is difficult, so you may want to trace one of the photos on pages 92 and 93 to get the rings just right. Draw it on tracing paper first, and then transfer it to your canvas.

Fill in the landscape. For the base color of this bizarre moon, use four parts burnt umber, one part black, one part burnt sienna, two parts white, and one part raw sienna. Depending on the brand of paint you are using, you may need to add a bit more or less white to get a mid-tone for the brown. When this is dry, sketch in the general guidelines of your landscape.

Step 02 Saturn itself is one of the trickiest parts of the painting. Study the photos on pages 92 and 93 carefully before laying down your color. For the body, use a mix of one part yellow oxide, one part raw sienna, and white as needed. Add a touch of ultramarine blue toward the pole. Remember that the belts must curve in the same way the rings do: They should be identical ovals but small enough to just fit the planet. The B ring, in the middle ring system, is the brightest; use white cut with a little yellow oxide. Rings on either side of this dense ring are fainter. Add a little ultramarine blue to tone them down. Faint rings bracket the main ones. Use a thin wash to indicate these, keeping your ovals concentric and even. Remember to show a hint of bright light on the night side of Saturn, where light reflects off the rings onto the tops of clouds.

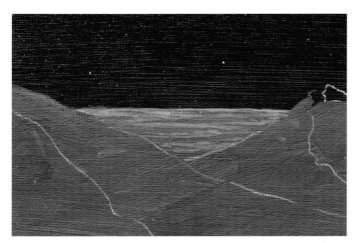

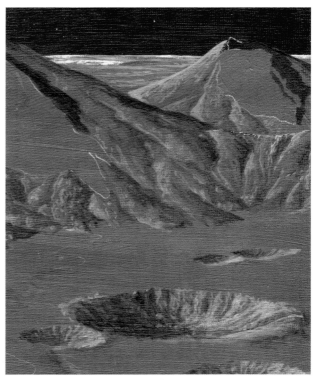

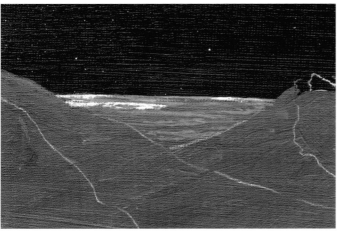

Step 03 Mix raw sienna and white and lay in some highlights on the distant plains behind your hills (*top*). You don't want these highlights to be too bright, or they will conflict with the bright terrain to come next. After your landscape highlights are defined, put in some bright white areas (*bottom*).

Step 04 Begin dropping in a mix of three parts burnt umber, two parts purple, and a touch of black for your shadows. Fill in your craters and define shadows at various rock outcrops. Remember to let the shadows define the contours of craters and hills. Lay in a set of highlights, using a mix of one part raw sienna, one part burnt umber, and white as needed. Keep these areas subdued so that when you put the white rock down there will be contrast.

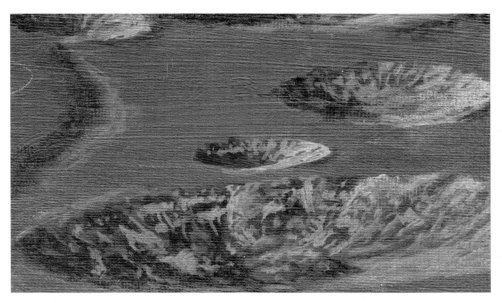

Step 05 Using the same techniques as in the painting of ancient Mars on page 62, lay in the white ice-rock in your crater floors. For areas in sunlight, use raw sienna and white. For white ice in the shadows, use purple, ultramarine blue, and a little white.

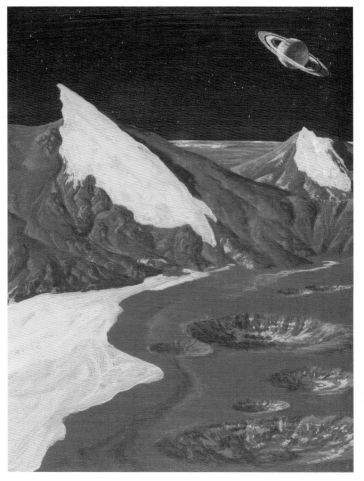

Step 06 Cover areas where your ice outcroppings and ice floes will cover the dark landscape, using colors that match your crater interiors.

Step 07 Lay in a foundation color for your shadows using purple, a little white, and a touch of ultramarine blue. As in your crater floors, you want this color to be very purple to pick up colors from your sky.

Step 08 Add highlights using a mix of raw sienna and white. These bright areas will need to be nearly white to cover the already light colors in your rocks and the flow on the foreground landscape.

Step 09 Wash some burnt umber over your shadow areas, letting the purples show through here and there. This lends a richness to the shadows.

Step 10 Add gravel using the technique described in step 10 of "The Earth from the Moon" on page 43. Cut separate masks for the bright ice areas (*left*) and the dark areas (*right*). Use essentially the same colors for dark and light gravel, but in the bright areas, go very easy on the dark stuff, and in the dark areas, emphasize it, using light gravel sparingly. Use burnt umber cut with a bit of purple for the dark gravel and its shadows. Use a mix of white and raw sienna for light gravel and highlights. Take this opportunity to spray a little dark gravel into the white rock face, and let some white gravel tumble down the hillside in little rivers. This gives the dark and light areas that natural interaction you're always after.

Use a detail brush to lay in a few large pebbles and stones, casting long shadows across the sandy texture overlaying most of the painting. Add a faint spray of deep purple to the shadowed areas. Your Iapetus landscape is complete.

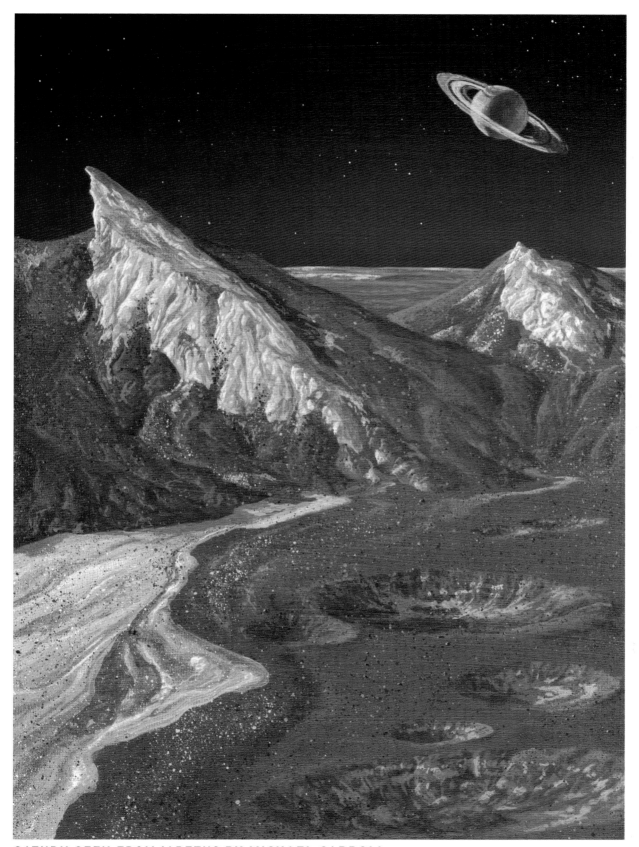

SATURN SEEN FROM IAPETUS BY MICHAEL CARROLL

A VIEW OF NEPTUNE FROM TRITON

LEVEL: INTERMEDIATE

In this lesson, we'll learn how to paint a really blue world, and we'll master the technique of painting blue and pink ice without it looking like somebody's baby shower. First, let's take a look at our subject.

Neptune is the fourth largest planet in the solar system, a gas giant that could hold seventy-two Earths. The planet orbits the Sun in the coldest depths of the planetary system. Neptune's deep blue atmosphere looks a bit Earth-like, but don't be fooled. This cryogenic brew has poisonous gases of methane, hydrogen, and helium. Bitter winds of over 1,500 miles per hour tear white ice crystal clouds into streamers and bands. Neptune has dark spots much like those of Jupiter. These storms last for months, then disappear without a trace.

Circling Neptune is one of the strangest moons known—Triton. Triton is about the size of Earth's moon, but it's made of ice rather than rock. At Triton's temperatures, water-ice becomes hard as granite, and nitrogen—which makes up most of what you're breathing right now—becomes a pinkish ice frozen to the surface. Triton has bizarre geysers of super-cold nitrogen that pour steam into the dark sky. These geysers leave dark streaks on the bright ice. Strange terrain dimples and scores the surface of the bizarre moon.

Standing on Triton, Neptune would be a beautiful sight. For your painting, you'll be looking across an icy plain with the sun at your back. Triton's thin fog of an atmosphere may brighten at the anti-solar point (the point in the sky directly opposite the Sun), so you'll put Neptune there, in the brightest part of the sky. Shadows will all point toward the same anti-solar point, leading the viewer's eye toward the giant blue world low in the sky. Let's get started!

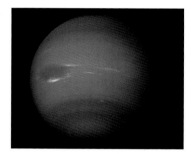

Voyager 2 captured the brilliant blue orb of Neptune during a flyby in 1989. (Courtesy NASA/JPL)

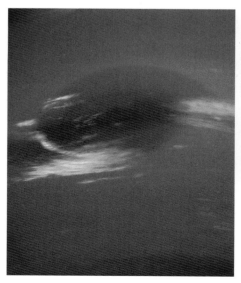

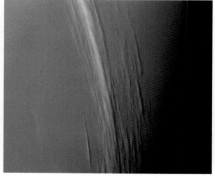

Swirling clouds provide stark contrast against the methane-blue globe of Neptune. (Courtesy NASA/JPL)

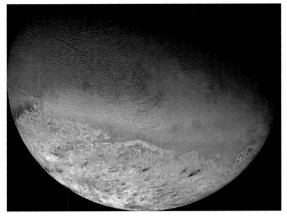
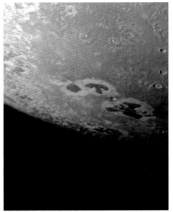

Three views of the surface of Triton. (Courtesy NASA/JPL)

The Plan Our view is from atop a ridge. Shadows from the ridge stretch across the frozen plains toward the horizon and provide a vanishing point. We'll add a couple calderas here and there for interest. As this painting will have washes and fine details, you may want to put a layer of gesso or white paint on your canvas and sand it before going to step 1.

Step 01 Lay down layers of black, ultramarine blue, and raw sienna, so that your sky fades from a glowing brown haze at the horizon to a deep blue-black above. Use those X strokes to keep things smooth.

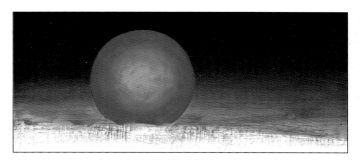

Step 02 Put down a blue ball, using about three parts ultramarine blue, one part phthalo blue, and a little white. Make the outside edge darkest, adding more white as you move in toward the center. Be careful with that outside edge—you don't want a lumpy Neptune!

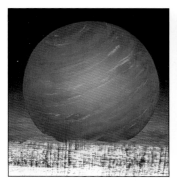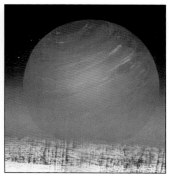

Step 03 Using the photos on page 100 as a reference, paint in some curving, dark belts (*left*). I like to use a soft, round brush so I can carefully render the blurry edges of these belts. They should be very faint. Thicken the belts into oval storms here and there. These storms resemble the Great Red Spot of Jupiter. Over these dark features, drape white methane clouds. Now, using a large, soft round brush, place a wash of raw sienna and white over the base of your sky along the horizon (*right*). Tap it out on the top with your finger or a sponge so it fades away.

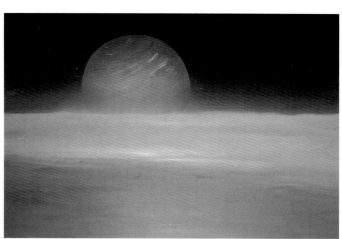

Step 04 Put a wash of ultramarine blue mixed with raw sienna on the horizon at left and right, so that the raw sienna fog fades away on either side. You can put the ground color in, using a mix of burnt sienna and ultramarine blue. These two colors provide a wonderful spectrum of metallic blues, browns, and grays. The burnt sienna is red enough to give us that subtle pinkish cast unique to nitrogen ice. It's a cool effect. The landscape shouldn't be mixed too evenly. Don't be afraid to let some of the color show through in places. This will give you some random color variation.

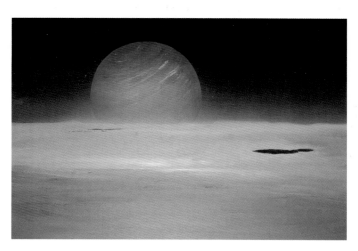

Step 05 Put in several calderas, using a mix of two parts burnt sienna, one part ultramarine blue, and a touch of raw sienna. Just like other craters, calderas that are closest to the horizon are flattest, while ones close to the viewer (lower on the landscape) will be more oblong.

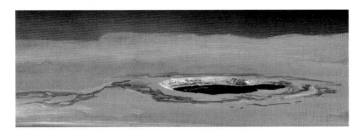

Step 06 Paint concentric circles around your calderas to indicate areas that periodically overflow, stained with cryolavas (super-cold lava of nitrogen ice floes). Give yourself a few little rivers here and there. On the face of your caldera, drop in some vertical lines to give a sense of the rim sloping down. Use the same highlight and shadow techniques that you've used on impact craters, but make this lip steeper.

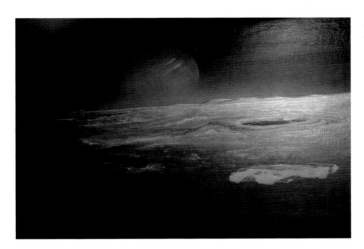

Step 07 To make an icy surface, you'll use a piece of wadded plastic wrap. First, water down some white paint and put a small, linear blob on your canvas.

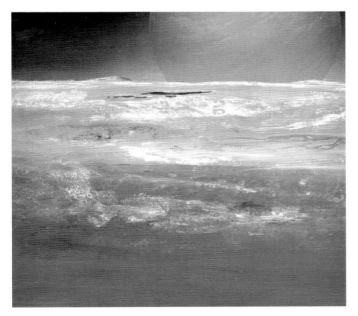

Step 08 Wad up a piece of plastic wrap and dab it into the puddle of paint. Make sure it covers all the edges of the wet area, but don't drag or twist it. Just press once. Hold it down for about thirty seconds so that the paint underneath begins to dry.

Gently pull up the plastic wrap. This is a great technique for ice, marbled surfaces, and many other textures. Don't reuse the same piece of plastic, as it loses its strength and "crinkliness." Repeat the process in other areas of your canvas to break up the ground into interesting forms.

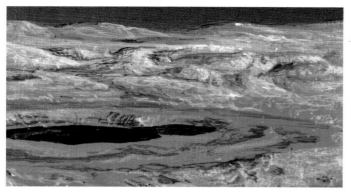

Step 09 Reinforce the random shapes in your plastic-wrap hills in the distance, using white wash for highlights and ultramarine blue and burnt umber for the shadows. This will give your painting an added feeling of three-dimensionality.

Once your plastic-wrap textures have dried, you can emphasize some of the areas with linear, flowing features. You'll do more of this soon.

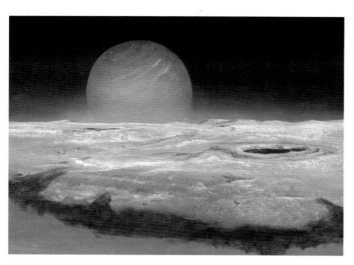

Step 10 In your foreground, put a down shadow wash of one part white, three parts burnt umber, and two parts ultramarine blue.

Leaving room at the bottom for your foreground ridge, stretch your soft shadow into points and bumps that all point into the distance to a single vanishing point just to the right of Neptune, on the horizon. It's important to remember where this point is, as all other shadows will point to this spot. Note how the shadows on the distant mountains also face toward this point, so that mountains on the left have shadows on their right side, while mountains on the right have shadows on the left, facing the vanishing point.

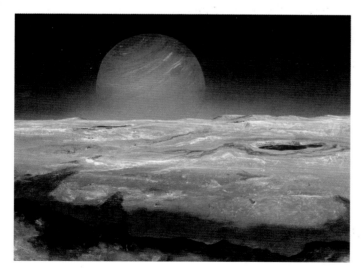

Step 11 Add the shadowed edge of your foreground ridge, using the same colors you used for your shadows, but with a little more burnt umber and a bit less white. The paint needs to be very thick.

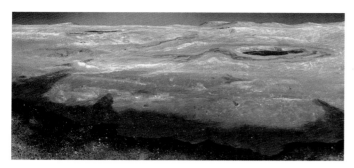

Step 12 Mask off the ridge and spray it with dark toothbrush gravel (see step 10 of "The Earth from the Moon" on page 43), using a mix of burnt umber, burnt sienna, and ultramarine blue. Over this, but not reaching the far edge of your ridge, add highlight gravel with ultramarine blue, burnt sienna, and white.

Step 13 Add a few large boulders with highlight colors, then paint some cast shadows from various stones and blocks that disappear into the shadowed side of your ridge.

Step 14 Since Triton is made up of ice, we can assume the surface will be quite reflective. Using a mix of phthalo blue and white, render some reflected light from Neptune on the far edge of the foreground ridge (the side of the ridge facing toward Neptune and away from us). The very edge of the ridge should be hard edged, with the blue fading softly into the shadows toward you.

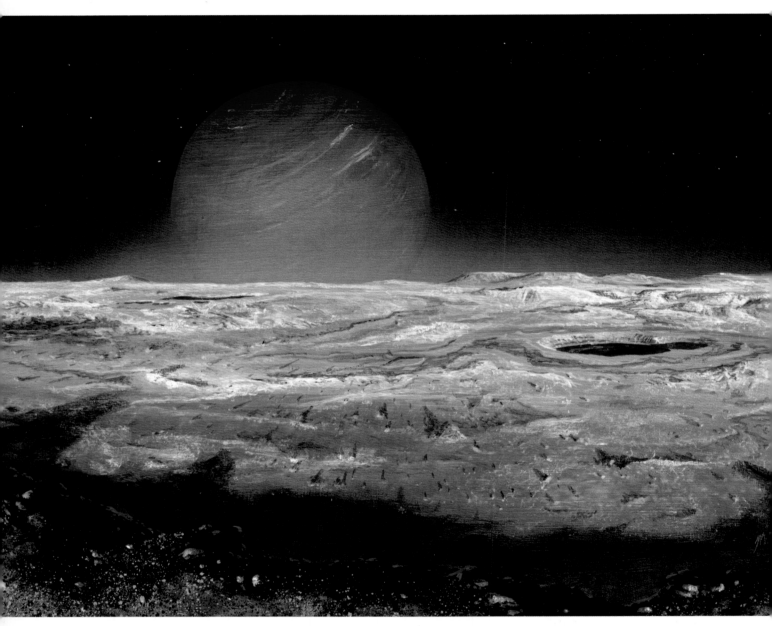

A VIEW OF NEPTUNE FROM TRITON BY MICHAEL CARROLL

Your signature completes a painting of one of the strangest moons in our planetary system and also completes our trip through the realm of the gas giants.

GUEST ARTIST
PAINTING ICE WORLDS BY DON DIXON

Most of the solar system is frozen. On Mars, the polar regions are so cold that carbon dioxide—the gas that forms the bubbles in soda—freezes to form vast fields of "dry" ice. Beyond Mars, sunlight is so weak that surface temperatures of planets are always below the freezing point of water, and ice becomes as hard as rock. Neptune's moon Triton is so cold that nitrogen—which makes up most of the air we breathe—forms an icy crust on the surface. It is a world whose "rocks" are made from frozen air!

To paint such worlds, an artist should remember that ice reflects light differently than rocky materials. Ice has specularity: It's shiny. Icy surfaces have highlights, or bright spots, where the sunlight is most directly reflected. Ice also shows subsurface scattering: Some sunlight penetrates below the surface and bounces around a bit. (Human skin also has this quality, which is one of the reasons most 3D animated characters look like they're made of plastic. Subsurface scattering is difficult to simulate.) Studying photographs taken in Antarctica is a good way to get a sense of how icy landscapes differ from rocky ones.

In painting extraterrestrial ice, however, one should also remember that different processes have shaped the landscapes of other worlds. Impacting meteorites often shatter the ice. Such fractured ice is usually very white, not clear. Also, the energy from cosmic rays or the Sun's ultraviolet radiation can turn methane ice dark brown or red. And, although it may be tempting to paint interesting icicle formations, the melting and refreezing process that produces icicles is unlikely on most worlds other than Earth, because there are few planets where ice can melt and exist as a liquid; on airless worlds, melting ice turns immediately into a gas.

Don Dixon is a freelance writer and illustrator specializing in astronomy, science fiction, and astronautics, in both digital and traditional media. His work has appeared in, and on the cover of, numerous magazines, such as *Omni, Scientific American, Smithsonian,* and *The Economist,* and over sixty books, including *Universe* (Houghton Mifflin, 1981), which he also wrote. Dixon was the concept designer for theme attractions at such venues as Epcot Center and Caesar's Palace, Las Vegas, and is the art director at the Griffith Observatory in Los Angeles.

Prolific space artist Don Dixon has a studio in southern California. (Photo by Anna Dixon)

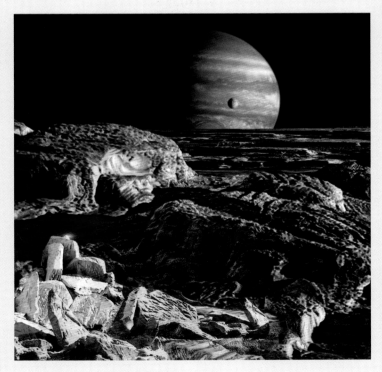

EUROPA BY DON DIXON

The cloud-striped globe of Jupiter peers over the horizon of Europa's north pole.

WORLDS BEYOND NEPTUNE

Beyond the orbit of Neptune, our solar system is ringed by a vast cloud of cosmic debris. Rocky asteroids and icy comets make up this donut of dark detritus called the Kuiper Belt. Many scientists include Pluto as one of many members of the Kuiper Belt. Dozens of other Kuiper Belt Objects (KBOs) have been charted in the outer darkness, including some that are larger than the wannabe planet Pluto.

Even farther out, across the empty expanse of space, other planets orbit exotic stars. One day we will undoubtedly find worlds with oceans of water or more alien liquids and other worlds simmering under the heat of massive suns. Getting a jump on science, in our last few paintings, we take some flights of educated fancy, guessing what might be "out there," awaiting travelers of the future.

PLUTO AND ITS MOON CHARON

LEVEL: ADVANCED

Pluto is a small world, so small that it is no longer considered a planet. Instead, scientists now group Pluto with a new class of objects called "ice dwarfs" or "dwarf planets." Pluto is an icy ball, no larger than Earth's Moon, and is a member of what may be a vast family of icy planetoids beyond the orbit of Neptune. These objects form a cloud around the Sun called the Kuiper Belt. Several KBOs (Kuiper Belt Objects) that are actually bigger than Pluto have been found.

Pluto's nature may be very similar to Neptune's moon Triton, which we visited in our last painting. It appears that the two are essentially the same size, color, and material. If this is so, Triton and Pluto may actually be siblings, both KBOs. (Triton's orbit suggests that it was captured by Neptune's gravity as it passed by.)

Pluto has at least three moons. The largest, Charon, is about 750 miles (1,200 km) across. Charon is so large compared to its parent planet that Pluto and Charon are a lot like a double planet.

Pluto has a thin atmosphere when it is closest to the Sun (at times its egg-shaped orbit carries it just inside the orbit of Neptune). But as Pluto makes its way farther out, the atmosphere collapses into ice. In this way, Pluto is like a large comet. Your painting will show Pluto with crystals of ice floating in a thin atmosphere. You'll have some fun with color as you show light filtering through translucent spikes of ice. For this painting, you're pulling out all the stops and letting your imagination run wild. Get out your artistic license and take off!

The best view so far of Pluto and its moons. Pluto is the large white object at the bottom, Charon is the bright blue dot above it, and the other objects are the recently discovered moons Hydra and Nix. (Courtesy NASA/ESA/H. Weaver [JHU/APL], A. Stern [SwRI], and the HST Pluto Companion Search Team)

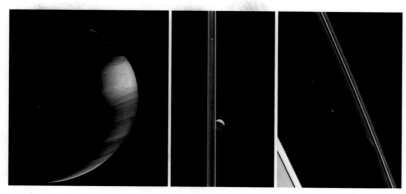

This painting includes a view of Pluto's rings, seen edge-on, as in these *Cassini* photos of various edge-on views of Saturn's rings. Notice how the ring system looks like a line when viewed this way. (Courtesy NASA/JPL)

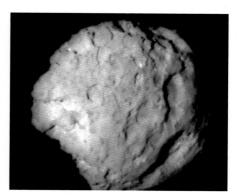

Some comets, such as Comet Wild #2, display spikes and rugged ice outcrops, similar to those found on Pluto. (Courtesy NASA/JPL)

In the painting, you will be depicting translucent ice. You can see in this photo taken in Alaska at the Bering Glacier how the light filters through in subdued color, a subtle version of the light in the sky behind. Shadows are darkest at the core, or center, while highlights are bright and firm, just along the edges. (Photo by author)

The Plan Your Pluto painting will have all sorts of interesting things close to the center line, pushing all those rules of composition out the window. The moon Charon will run off the top of the painting, but its cusps will be firmly within the frame. Directly below will be the faint Sun, and below it another small, irregular moon. Just to one side is the straight line of a faint ring, and around the Sun, overlapping Charon, is an ice-crystal halo.

Step 01 Your Pluto painting will be a symphony in blues and browns. To begin this icy landscape, mix a horizon line of three parts white, one part ultramarine blue, and two parts burnt umber. Your horizon should start about one-third of the way down from the top of your canvas.

Step 02 Work up into your sky with more and more ultramarine blue, adding purple as you get higher. At the very top, work in enough black that your sky becomes quite dark but still has rich color.

 Below the horizon, continue adding burnt umber with just enough ultramarine blue to keep it cool.

Step 03 Draw in Charon and your horizon line. Apply a spray of toothbrush stars (see step 1 of "The Earth from the Moon" on page 39), being careful to shield your landscape from the spray.

Step 04 Begin the Sun with a fuzzy layer of acra violet mixed with a little cadmium yellow and white. This color must be rich, as it will have to show through the white glow of the Sun. Give it a diagonal spike of light emanating directly from the center.

Step 05 Add a white wash to the Sun and tap it out with your finger so that it forms a glow all around the crimson spot. Finish it off with pure white at the center, jabbing out into several sharp lines of light around the Sun.

Step 06 Dampen a sponge and load it with titanium white in the center, a spot of acra violet on either side, and a smaller spot of ultramarine blue on the outside. Drag this vertically, letting the paint tail out at the lower end.

Step 07 With a damp flat brush or a clean sponge, streak across the reflected colors to blur them horizontally.

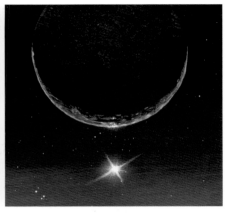

Step 08 Fill in the crescent of Charon with a mix of raw sienna, burnt sienna, and white (*left*). Make the first coat rich in color, with shadows defined only by the dark sky showing through. Using a sponge, dab on some crater textures with a combination of burnt sienna, raw sienna, and ultramarine blue. You may also need a touch of white to contrast with your sky, but keep the overall effect very dim, as this is the "dark side" of Charon.

Add brighter highlights to the crescent, letting them fade away at the cusps (*middle*). Bring the dim blue-gray of the dark side to the edge of your circle, but let it fade out toward the crescent. Erase the pencil lines and add a few pure white sparkles on your crescent just above the Sun (*right*).

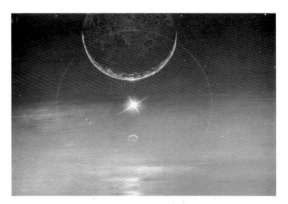

Step 09 Using a white wash, paint in the dark side of one of the smaller moons below the Sun. The crescent should be a mix of white cut with a little raw sienna. Its shape should be very irregular, much like the moons of Mars.

The most difficult part of the painting will also be the most spectacular: an icy halo. To start, trace a wide ring around your Sun with a white pencil. This halo circle should be a little more than half the diameter of your canvas, centered around the Sun itself. Leave the pencil circle sitting on your sky as you progress to a different sort of ring in the next step.

Step 10 Some researchers believe Pluto has a faint ring around it, fed by dust coming from its smaller moons. In this view, the ring will be vertical, as if we are standing at the equator of Pluto. You'll define this ring using masking tape and thin paint applied with a toothbrush. The color should be very dark, just brighter than the sky. Lay your masking tape vertically in two parallel strips, just to the left of your Sun.

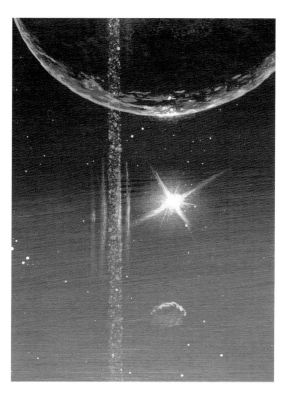

Step 11 Use a toothbrush to spray a fine, dim line of white paint between the strips of tape. Add some brightness along the ring just where it intersects the top of the halo line. Gently strip off the masking tape and add some secondary ring lines with a fine detail brush, using the shots of Saturn's rings on pages 92 and 93 for reference.

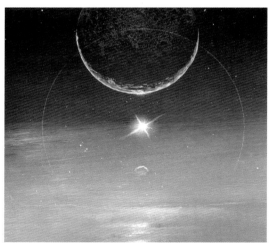

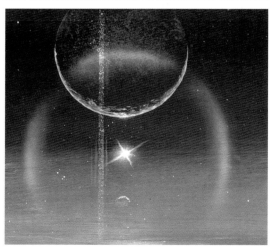

Step 12 With a sponge or soft brush, lay on a faint, thin line of white paint along the inside edge of the circle you drew for the halo, avoiding the line itself (*top*). Dab on the paint a little at a time, tapping out the edges with your finger so that it fades away on the inside and outside of the halo. The halo should not go all around, but should be brightest at points even with the Sun on either side and directly above it. After this coating is completely dry, erase the pencil line.

Your white halo base coat *must* be completely dry before moving on. If it isn't, the colors that you wash over the top of it will lift the white off your painting. With a soft detail brush, dab on some thin, cadmium yellow paint in the center of the halo line, tapping out the edges as you did with the white. On the inside of your halo, brush in some acra violet mixed with cadmium red (50/50). On the outside of the halo, brush on just a hint of phthalo blue. This blue should have a green cast where it meets the yellow center of the line. Be patient with this process, taking it in small steps so that the washes blend well (*bottom*).

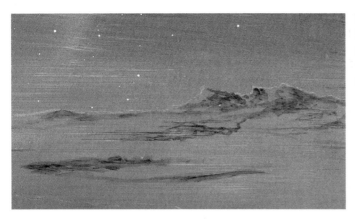

Step 13 Along your horizon, lay in distant hills. Begin with shadows, mixing burnt umber and ultramarine blue with a touch of white as needed (*top*). Over these shadows, put down highlights using thin white paint (*bottom*).

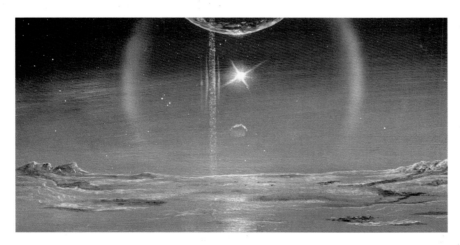

Step 14 Work your way down, rendering craters and valleys. Leave some areas bare for the next addition: bright rayed craters.

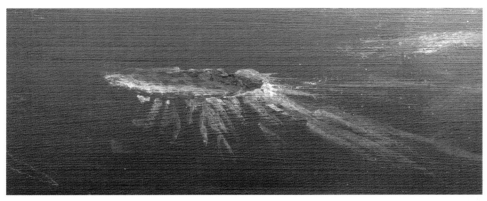

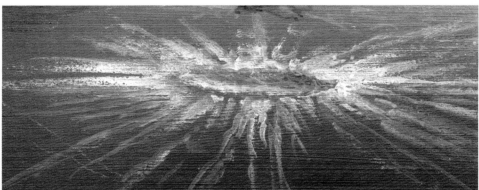

Step 15 On many icy moons, some craters are ringed by a halo of bright ice that forms an elegant radial crown of lines (these are called rayed craters). Make several of these bright craters. First, define the rim lightly with a white wash. Then, put beads of white along this line. Drag each bead away from the crater rim, letting it fade out as it extends away from the crater (*top*). Because of perspective, lines at the far center will be shortest. Continue adding rays all around each crater (*bottom*).

Step 16 Indicate patterns of ice by putting down faint geometric forms with a thin white wash (*left*) and then firming up the edges with blue-brown shadows and white highlights (*right*).

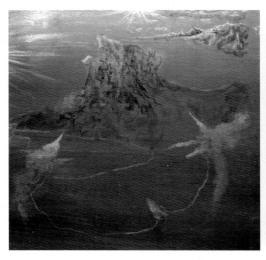 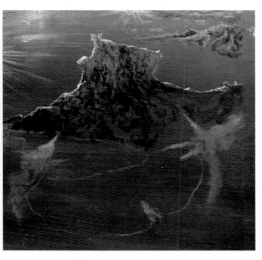

Step 17 Before you paint your translucent ice, look at the photograph of ice on page 111. Begin your icy wonderland by mixing acra violet, cadmium yellow, and white. Sound familiar? These are the colors you used for your sunlight. Use the brightest paint at the tips of your hills and promontories nearest the Sun. As you move deeper into the hill and away from the Sun, fade the color into more crimson and violet, then ultramarine blue mixed with white (*left*). Keep that blue fairly dark. Make these colors work for you, defining the way the terrain slopes and undulates. Add dark lines for the darkest core areas, using a mix of ultramarine blue and burnt umber (*right*).

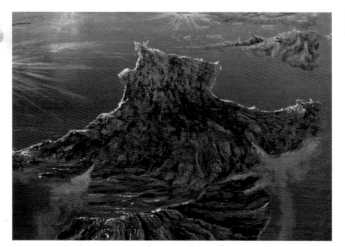

Step 18 As in step 17, work your dark lines so that they define the form of the landscape.

Step 19 A study in icicles. Define the icicle shape with the same colors, giving the effect of sunlight coming through the ice (*left*). Add a dark core and overlay bright highlights (*right*). Tap out the highlights on the edge farthest from the sun so that they are softer and allow the color to show through more than the harsh direct highlights. Give your white lines spots and breaks to lend a sparkle to the scene. Your landscape on Pluto is complete. This painting uses a large dose of imagination, but one thing is certain: It's quite an alien world!

Opposite: ***PLUTO AND ITS MOON CHARON*** **BY MICHAEL CARROLL**

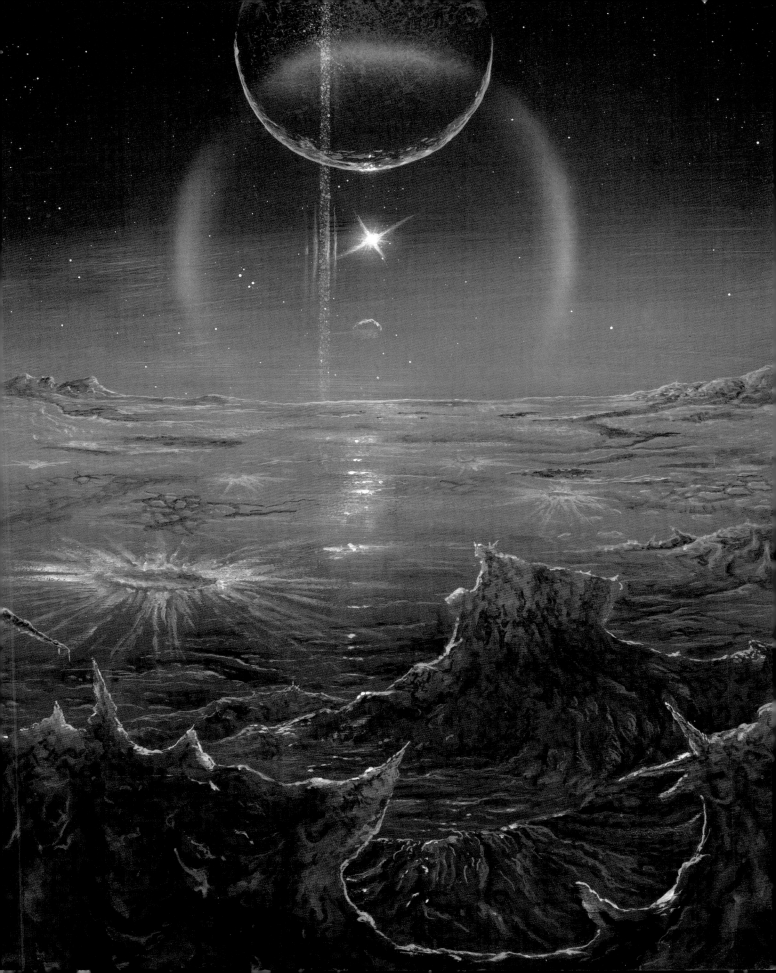

MELTING WORLD WITH TWO SUNS

LEVEL: INTERMEDIATE TO ADVANCED

Unlike our solitary sun—to whom the nearest star, Proxima Centauri, is 4.3 light years away—most stars have companions. (A light year is the distance light travels in one year; since light travels at 186,000 miles each second, a light year is approximately 5,865,696,000,000 miles.) Proxima Centauri is a member of a three-star system. The other two stars are much like our sun, but Proxima is a small reddish star called a red dwarf.

There are undoubtedly many planets out there with more than one sun in their sky. What a strange and wonderful experience it would be to have two sunsets, two sunrises, varying days, and differing seasons! In this painting we'll explore one such hypothetical world.

Your planet is going to be a hot one. Circling near two suns, its rocky surface will glow red. Searing lava will flow across the surface. And since you have two suns, you will also have two sets of shadows!

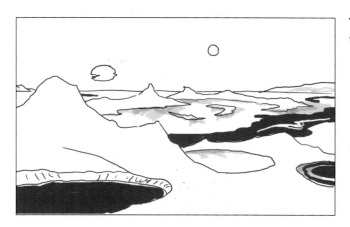

The Plan Your melting world will have two suns. The tan landscape will be cut with dramatic dark red lava flows.

Step 01 Put down a bead of white about one-third of the way down your surface; this will be your horizon. Above this, work in raw sienna and cadmium red, then acra violet, and, finally, darken the sky with ultramarine blue cut with a bit of white to keep it from getting too dark. You want your painting to be filled with light.

Below your horizon, add raw sienna and burnt umber, darkening to a medium warm tone at the bottom of the painting.

Step 02 Blend the colors together with broad, smooth X strokes.

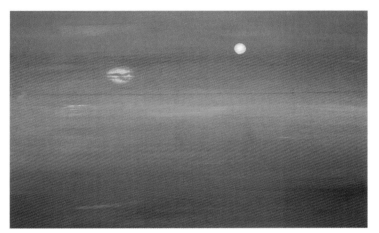

Step 03 Just above the horizon, lay in a yellow-orange sun using cadmium red and cadmium yellow. This star will be oblong, a combination of atmospheric effect and physical state: Some stars are not round! The orange sun will be broken by layers of haze. Indicate this by leaving unpainted horizontal areas. Be sure to use more yellow toward the center to give the effect that the sun is glowing.

Mix white with raw sienna and add a white-hot star to the right, using white with raw sienna. Use more raw sienna to make the edges of your white sun a little darker than the center.

Step 04 After detailing both suns, add a wash of yellow around the yellow-orange sun and white around the white sun to make them really glow. Drag some of the yellowish color of the yellow-orange star horizontally to define the ragged edges of clouds.

Once your glowing suns are in their proper places, sketch in the guidelines of your painting.

Step 05 Lay in distant hills, using burnt umber and acra violet for shadows. Your highlights will vary, depending on whether your mountains are closest to the white sun or the orange one. For those closest to the yellow-orange sun, use a mix of raw sienna and yellow with white (*top*). The more pure light of the white sun requires only white and raw sienna for the highlights (*bottom*). Let a lot of the sky color show through; these mountains are far away.

A WORD ABOUT SHADOWS

When you have two light sources, such as two suns, each casts its own set of shadows. When these shadows overlap, things get a bit tricky. Let's say your first light source is orange. It will cast a shadow that looks nearly black in its own light. But if we now add a second, blue, light source, another shadow is cast. If the blue light were the only one there, the shadow it cast would be nearly black as well. But the blue shadow has orange light partially filling it, and vice versa. The only place where the shadows are really dark is where both shadows overlap.

Each shadow takes on the cast of the opposite sun.

Step 06 Add horizontal shadows and hills near the horizon with a mix of burnt umber and acra violet. Let a lot of the sky show through here as well. As you work your way down, use less and less violet, finally defining your terrain using only burnt umber. Add highlights as you did in step 5.

Step 07 As the ridges become closer to you (lower on your canvas) add a wash of raw sienna, letting the irregular watery paint create textures. Before detailing these areas, check out "A Word About Shadows" to help you understand the complex lighting of this painting.

Step 08 Apply dark washes of burnt umber to add texture to the dark side of your mountains, defining slopes and hollows with the linear forms (*left*). Tap out those lines, keeping them soft. Add highlights carefully, making sure the light matches each star. Now tackle the shadows (*right*). Referring to the diagram in "A Word About Shadows" on page 122, use a wash of ultramarine blue with a hint of white for shadows cast by the warm sun. Use a wash of burnt sienna with some burnt umber for shadows cast by the white sun. The overlap should be darker (you can fudge it by adding some ultramarine blue if you need to). Be careful of your control on this step; it can be challenging, but you are up to it! Just add small bits at a time, and let each wash dry completely before adding more on top.

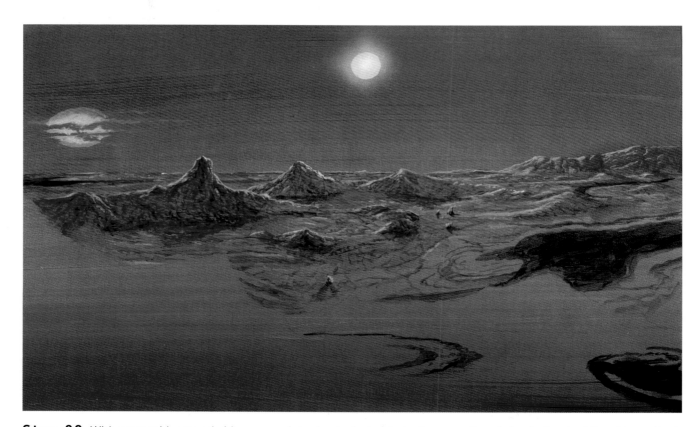

Step 09 With your mid-ground ridges complete, begin laying in textures on the plains in front of the ridges. Dark lines will continue into your shadows. At this stage, add a mix of black, burnt umber, and white for your dark lava flows. Remember: As the flows extend closer to the horizon, they become flatter and more linear (note the flow at far left).

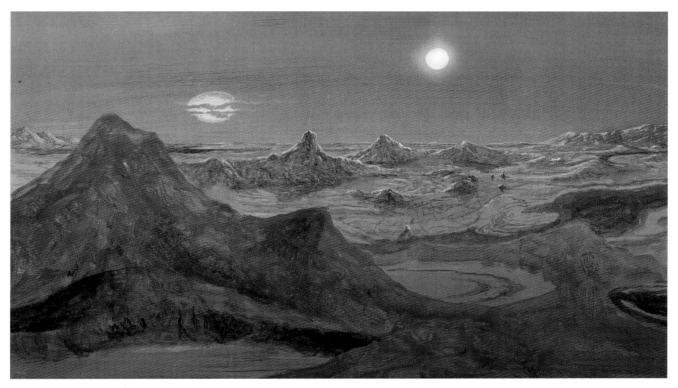

Step 10 Using the heel (side) of a soft round brush, dab on thin layers of burnt umber textures. Let these textures define the slopes and hollows of your foreground hills. Add in shadows using burnt umber and a little ultramarine blue.

Step 11 It's time for some drama—lava! Lay down thick black, yellow, and cadmium red paint and use a fairly small brush to intermingle the colors while they are still wet.

Step 12 Using burnt umber, raw sienna, and white, lay in some faint highlights. On this painting, we actually have three light sources: two suns and the ambient light of the sky. On the sunlit side, add firm, bright highlights. Mix acra violet with ultramarine blue and white for the subtle highlights that face away from both stars. This treatment will be needed on both extreme sides of the painting where the hills lie outside of the direct light of either sun.

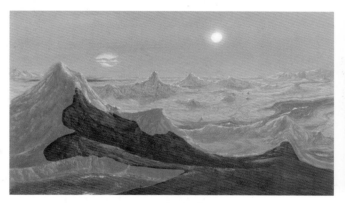

Step 13 Use a toothbrush to add gravel of white mixed with burnt sienna to the closest ridges for extra texture (see step 10 of "The Earth from the Moon" on page 43). Mask the areas of the painting where you don't want gravel (*left*). On each of the larger pebbles, add pairs of cast shadows (*right*).

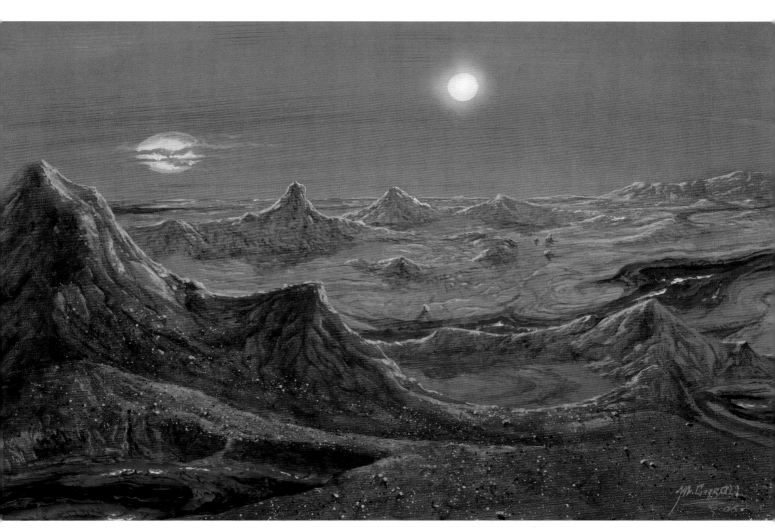

MELTING WORLD WITH TWO SUNS BY MICHAEL CARROLL

Congratulations! Your double-sun melting world is complete. This is a difficult painting, but the techniques you've learned will help you to subtly render light in a variety of landscapes.

THE ROCKY SHOW

LEVEL: BEGINNER

Our sun and the planets of our solar system began as a vast cloud of cold dust and gas. The cloud was thickest at its center, and the laws of gravity dictated that the cosmic blob begin to spin into a disc shape.

Within this primordial cloud, small grains of dust and rock stuck to each other, becoming piles of rubble. These piles combined into larger piles, and before anyone could do anything about it, mountain-sized asteroids were plowing into each other, creating even bigger piles of space rubble. Since every object has its own gravity, and the bigger the object, the more gravity it has, these heaps of cosmic debris began to take on more and more stuff, getting heavier and heavier. Eventually, these piles collapsed in on themselves from their own gravity, becoming the planets and moons we see today. The Sun gained so much material that its atoms actually collapsed, beginning thermonuclear fires in its heart. In the early days of the solar system, asteroids and comets continued a steady rain onto the planets. We see the scars of this epoch on nearly every solid face of planets and moons. (Earth has quite a few craters, but they have been heavily eroded by weather and the movement of the Earth's crust—a process called plate tectonics.)

We can see similar processes still occurring today in distant nebulae, where stars and new planets are being formed. We'll call our rendering of this first, formative age of a solar system *The Rocky Show.*

Stars are forming in these three examples of cosmic clouds, called nebulae. From top to bottom: the Helix Nebula, the Great Nebula in Orion, and the Eagle Nebula. (All images courtesy Space Telescope Science Institute)

The Plan There is no up or down when you're floating around in space, which is exactly what you'll be doing in this painting. Compositionally, this gives you all kinds of choices for doing a vertical or horizontal composition. You can even hang your painting upside down when you're finished!

A bright halo of light and color from the infant sun filters through the firmament, obscured by your floating asteroids. The brightest part of the canvas will be off-center for interest, balanced by large foreground and mid-ground asteroids. The closest asteroid is the one you'll be standing on (unless you want to be floating under it, in which case you can put it at the top or side—isn't space art fun?).

Step 01 Begin with the halo of bright light. Put down white at the center, ringed by cadmium yellow and cadmium red. Outside of these colors, you'll work in some burnt sienna, then ultramarine blue, and finally dioxazine purple with just a touch of black. Mash the paint into a colorful mix using your X strokes.

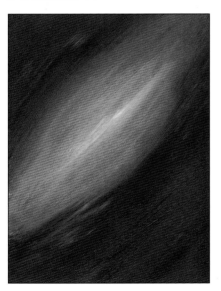

Step 02 Softly blend your colors with a large, flat brush. When this paint is dry, you can add washes as needed to smooth out the effect. You want your sky to be light enough that black shapes will show up even in the darkest corners.

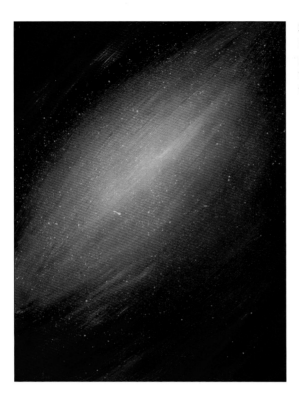

Step 03 Your toothbrush will come in handy for this rocky scene (see step 1 of "The Earth from the Moon" on page 39). Use very wet paint for larger blobs, drier paint for more distant ones. Lay down a field of yellow dots, ringed by red-orange ones as you work out from the center. These will become distant clouds of floating rocks.

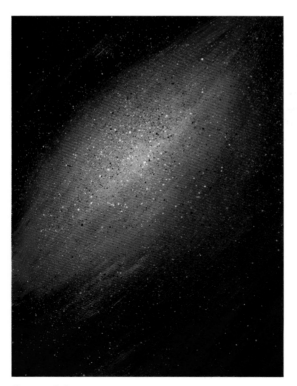

Step 04 Now work in some black specs, along with a central area of a few bright white ones.

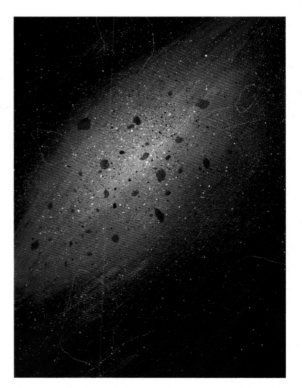

Step 05 Sketch in your larger asteroids. Using a mix of two or three parts cadmium red to one part black, paint in some distant boulders. Keep them random in shape, size, and distribution. You want them to appear distinctly lighter than the black silhouettes you will put in next.

Step 06 Paint in the rest of the asteroids in silhouette using pure black. Make sure some of them overlap for a dramatic effect.

Step 07 Using a mix of raw sienna, yellow, and white, paint in highlights on the black and deep red asteroids. As objects get closer to the center, these highlights will fade away so that we see only silhouettes in that bright central region. Make sure all of your highlights face toward the central bright area of your sky. On the larger asteroids, you can add more detail.

Step 08 On your closest asteroid, drop in a few sponge rocks as you did in earlier paintings (see "Mars from Deimos" on page 56, for example). Don't worry too much about shape; you can clean up the sponged areas with black paint to make the form just right. Add highlights to the rocks and firm up their shadows.

Step 09 Use a mix of ultramarine blue, white, black, and a hint of purple to fill in details on the dark sides of the larger asteroids. Keep this paint thin and tap it out with your finger so that it fades away. You want these details to be very subtle and faint!

Spray in some toothbrush gravel on your foreground asteroid (see step 10 of "The Earth from the Moon" on page 43), leaving lots of black area. The gravel should be most prevalent toward the edge of your rock, where the highlights are. Now you have a nice little rock to stand on and a fine painting of the formative years of a planetary system! For extra amusement, try hanging it on the wall upside down.

Opposite: ***THE ROCKY SHOW***
BY MICHAEL CARROLL

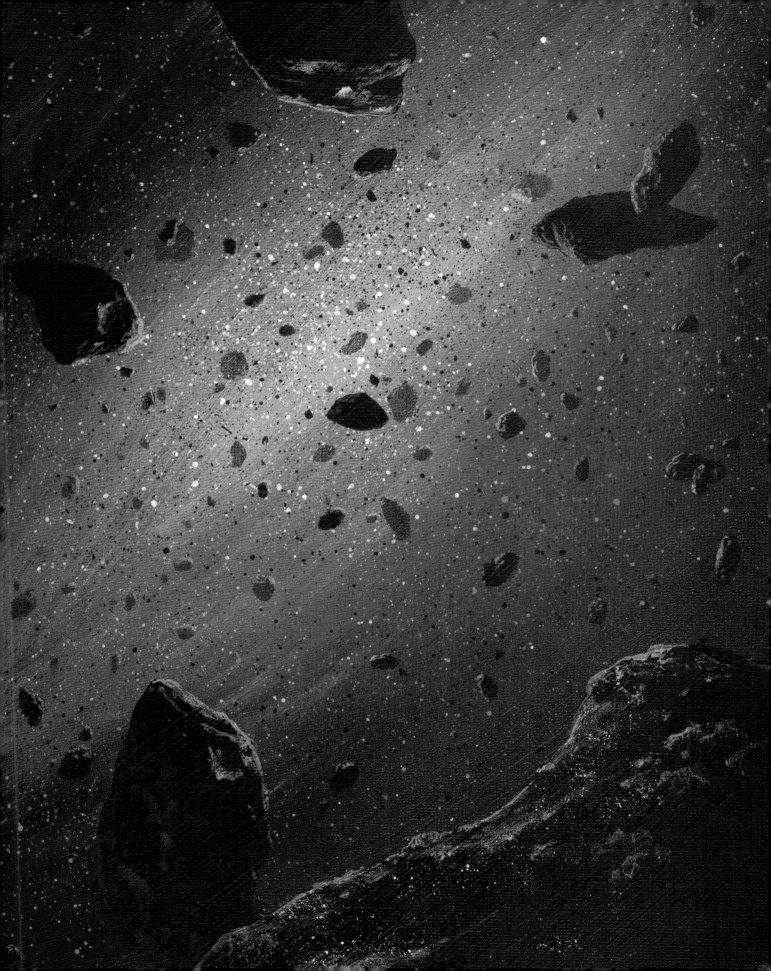

GUEST ARTIST
STUDYING AND PAINTING ASTEROIDS AND COMETS BY DAN DURDA

My full-time job as a planetary scientist with a research focus on asteroids and asteroid impacts has certainly influenced my part-time role as an astronomical artist. To me, the asteroids and other small solar system bodies aren't mere lumps of rock and ice: They're fascinating "fossils" of planetary formation that provide important clues to the earliest history of the solar system and our own planetary home. Each of the asteroids and cometary nuclei we have so far investigated via advanced remote observations and during encounters by our spacecraft emissaries has proven to be a uniquely fascinating world. Some are smooth and round, most are lumpy and irregularly shaped, and all have impact craters of various sizes scarring their dark and dusty surfaces—testimony to the violent collisions that dominate their lives. A fair number of them even have their own tiny moonlets!

I usually begin paintings of asteroids with a variegated "blob" of dark gray-brown pigment. This serves to block in the irregular, shadowy outline of the object and provides some random suggestions for where the lumpy swells and swales will go. Although I may have a preliminary idea as to what my asteroid might look like, I find this process to be rather organic, and the object will usually evolve its own shape and character. I then lighten the shadow pigment and begin to lay in the highlights of the sunlit side of the asteroid, following the feel of the "lay of the land." Once the basic hills and valleys are laid in, the craters follow. It is very important to get the look of a cratered landscape. Nature makes a lot more small craters than large craters, so you have to remember to not make a whole bunch of similar-sized, cookie-cutter holes across the surface. I've spent hours painting many sunlit rims and shadowed bowls only a millimeter across in some of my asteroid paintings! Some sandy-looking rocky debris here and there provides the final detail, and a new minor planet is ready to brush past a familiar blue planet.

Artist Dan Durda floats in "zero G" aboard a NASA research aircraft. Notice his patch commemorating the IAAA floating next to him. (Photo by Mark Cintala, NASA/JPL)

Dr. Daniel D. Durda is a planetary scientist whose research focuses on the collisional evolution of asteroids. He has published dozens of articles popularizing planetary science and human exploration of space, and his astronomical art has appeared in many magazines and books and has been exhibited internationally.

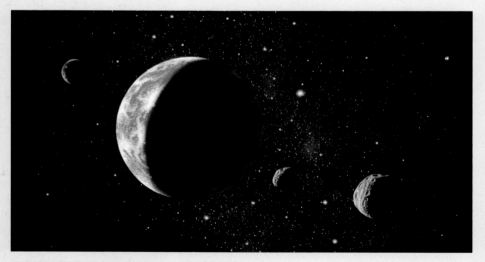

DOUBLE TROUBLE BY DAN DURDA
In this painting, rocky moons orbit an Earth-like world orbiting another star. (© Dan Durda)

WATER WORLD

LEVEL: INTERMEDIATE

When we look out into the depths of the universe, we see glowing clouds of gas called nebulae. Nebulae are the cradles of stars, nurseries of new suns. Within these clouds of dust and gas are the building blocks of stars and planets. And in every one of these cosmic clouds, in every direction we point our telescopes into the cosmos, we see water.

Most of the water in the universe is tied up in the form of ice. It floats in dark clouds of star stuff, zooms around stars as mountain-sized icebergs called comets, and even makes up large moons and small planets, as we saw on Pluto and Triton. It's likely that, as we move out into other star systems, we will find worlds covered with water, both as frozen wastelands and as sloshing oceans. Some of these worlds might even be like Earth, and many will be moons of giant planets. In many star systems, we have detected Jupiter-sized planets as close to their stars as Earth is to our sun. If any of these giant planets have moons like the icy ones we see orbiting the gas giants here, these alien moons will be awash with liquid oceans across their surfaces. This is the scene you will depict for our final piece of space art, *Water World*.

For this painting, you'll learn the basics of painting a seascape at sunset. It's an alien ocean with weird planets above, but the forms in the water will follow the same natural laws that they do here on terra firma.

Use these photos as reference for the crashing waves and foam in this painting. Notice the dark foundation of the splash (*top*). The foam (*bottom*) has a beautiful randomness, as small bubbles and thin trails of foam build into larger ones. (Top photo © Bill Gerrish; bottom photo by author)

The Plan Our blue sky will be blessed with a gigantic Jupiter-like planet. Around this planet, we'll see a couple distant moons, and we'll be standing on another one. The crescents must point directly toward the light source, the alien sun at the horizon. This sun will shine out from under the marine layer of clouds. For good measure, we'll put in some distant islands and peninsulas.

Step 01 Sketch in your horizon and the spot where your sun will be. Start with a brilliant blue sky: On your top layer, alternate ultramarine and phthalo blues. Beneath that, a layer of ultramarine blue will begin to gray the sky out (the phthalo is too blue for a sunset sky). Use your X strokes to blend. Bring your sky down a bit more than one-quarter of the way.

Step 02 The fattest part of your crescent—at the equator—needs to point directly at your sun. The cusps will point directly away. The smaller crescent moons will point in the same direction and be miniatures of their parent planet in form. Paint in the bright limb first, using a mix of raw sienna and white. Sketch in the belts, then paint in soft cloud features, letting them fade into the sky color. Remember: When viewed through a sky, the darkest part of your planet can *never* be darker than the surrounding sky.

Step 03 Your clouds are going to be ragamuffin affairs, wispy and torn by the wind. Be creative with your ragged cloud shapes! First, lay in the highlights. Use white, raw sienna, and a touch of acra violet. As you work down closer to the horizon, these colors can become richer. The base of your cloud deck needs to be quite thick, covering another quarter of your canvas.

Step 04 Paint in the shadowed sides of the clouds, being careful to let the highlight colors show through and surround the cloud shapes. Use a mixture of ultramarine blue, burnt sienna, and just a touch of dioxazine purple. Add just enough white to keep it foggy. More highlight should show on the bottom than on top.

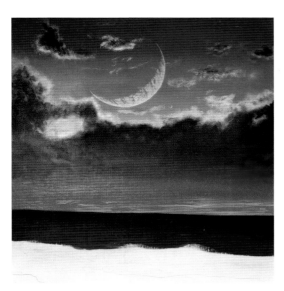

Step 05 At your horizon, lay down a bead of pure cadmium yellow and work this into the cadmium red above it. As your cadmium red moves upward, gradually mix in the dark cloud color so that the red fades away into the dark clouds above. Leave some streaks of yellow in the red for cloud texture.

Mix three parts ultramarine blue to one part phthalo blue and one part burnt sienna. Add less white than any other color, and fill in the ocean at the horizon. Keep the horizon horizontal! Measure the edges of your canvas so you don't have a leaning ocean (leaning oceans can be very disturbing, not to mention messy). Bring this color down to the area that will be the top of your wave, adding a little white as you go.

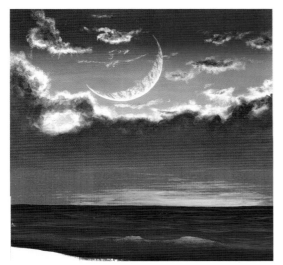

Step 06 Distant waves are horizontal, with only slight vertical undulation. Waves near the horizon are very close together. As the waves approach the foreground, they spread out, leaving more of the dark ocean base showing through. Keep it random, but give those waves a consistent scoop and dip that overlaps with each successive layer.

Your big foreground wave needs to be scalloped (see "the Plan" on page 135). At the top of the highest mounds, add cadmium red and yellow and work this into a little phthalo blue. Your orange glow should turn green as it disappears into the deeper part of the wave below.

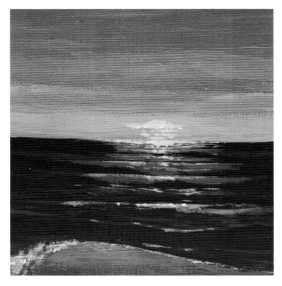

Step 07 Add red color to the light waves you have put down. This red needs to bracket the area where your sun will be. Make two vertical rows of red waves. On top of these, put a mix of cadmium yellow with just a hint of white on top of the red waves. The yellow will form a central column of waves reflecting the sun's glare. White spots here and there provide a shimmering appearance. Place your sun above, broken up by the reddish fog, much as you did for the orange sun in "Melting World with Two Suns" on page 120. Your sun should be roughly round but stretched out horizontally and painted in several strips showing through the cloud layers.

Step 08 Bring the dark blue of the water down the canvas, adding phthalo blue and raw sienna, with just a bit of yellow ochre (yellow oxide) or cadmium yellow in small increments. You want the water to begin to take on the tone of the beach below. For the beach, mix a neutral tone of raw sienna with a little ultramarine blue and white.

Step 09 Mask your ocean water and sky, leaving only the sand and the most shallow water areas open. Use your toothbrush effect (see step 1 of "The Earth from the Moon" on page 39) with very fine dots to cover the beach, first with dark brown sand grains and then with a light color consisting of raw sienna, white, and just enough ultramarine blue to keep it fairly gray. The edge of your water should hit the shore as rounded shapes.

Step 10 The foam will define your ocean surface. Note how in the photo on page 135, the foam forms linear shapes. These foam islands are torn and spread by currents. You can use the foam to show the curve of the wave or the flatness of the ocean surface. Keep each strip of foamy bubbles different from the last. Notice how the foam gets thicker and has small holes in it at the leading edge of the water along the beach.

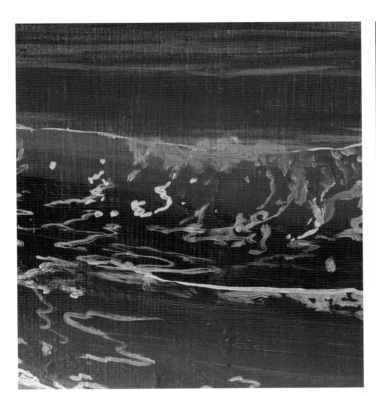
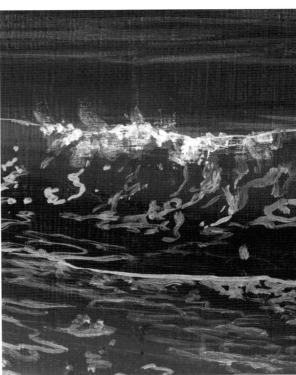

Step 11 Your waves are crowned with brilliant splashes of mist and spray. Put down a mix of ultramarine blue and white, cut with just a touch of burnt sienna (*left*). After defining the area, use a dry brush with pure white paint to brush on the highlights (*right*). Let your blue show through from underneath. Gently sweep your brush upward to indicate mist blowing off the top. Finish defining the little waves, valleys, and hills in your surf. Keep that texture random!

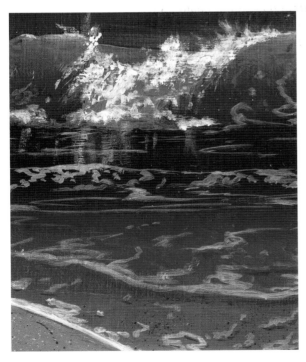

Step 12 Put a white dot of very watery white paint at the base of your wave, just under the splash area. Drag it down horizontally with a soft brush or sponge. This gives the effect of reflection in the flat area of the surf. Put in as many reflections as you need to mirror the splash form above.

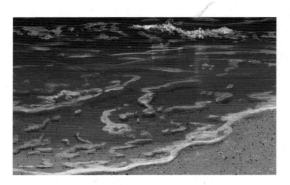

Step 13 Drop some shadows beneath the foam, each one echoing the foam above it. Use a mix of equal parts ultramarine blue, phthalo blue, and burnt sienna. Tap the shadows out with your finger as they move away from shore. As the water gets deeper, shadows will fade away. They also separate more from the foam as the sandy bottom gets farther from the surface of the water.

Step 14 Now render some distant cliffs using highlight and shadow, leaving lots of the sky color showing through. This will give a feeling of great distance. First, define the leading edges of your cliffs with faint highlights, using two parts white mixed with cadmium yellow and raw sienna in roughly equal parts.

Step 15 Finally, drop in shadows using a mix of black and raw sienna or burnt umber. Keep these shadows thin, tapping them out often to soften the effect.

To complete my water world, I put in the remnants of some ancient alien creatures. You can keep yours as a pure landscape if you prefer. You're the artist.

Opposite: **WATER WORLD BY MICHAEL CARROLL**

GUEST ARTIST
PAINTING WORLDS AROUND OTHER STARS BY LYNETTE COOK

Painting extra-solar planets is exciting work! It is such fun showing people what distant worlds—worlds that we can't see up close, even with our biggest telescopes—might look like.

How do I know what to paint? I use our solar system as a guide to how planets around other stars might appear. Astronomers think that most of the exoplanets—planets outside our solar system—could look similar to Jupiter, the largest of our gas worlds, since most of the extra-solar planets discovered so far have a mass equal to or greater than Jupiter. So when I paint an exoplanet, what I do is paint a planet similar to Jupiter, but without copying it exactly. We also know that our four gas giants have rings and moons. As a result, it is possible that gaseous exoplanets have rings and moons, too.

In *HD38529 System*, I am combining all of these elements into one painting: a ringed gas giant with satellites. The landscape at the bottom of the image is one of the moons, and it shows an icy surface with plates and ridges something like Jupiter's moon Europa. The star is so far away that this is a very cold place, too cold for liquid water to exist.

This painting began as a white, blank sheet of illustration board. I used an airbrush with acrylic airbrush paint to lay down the broad areas of color. Then I went in with colored pencils and gouache to add the details. The starfield in the sky was done by spatter painting with a toothbrush.

Lynette Cook in action, working on a mural for the Downing Planetarium at California State University, Fresno. (Courtesy Downing Planetarium; photographer: Akira Kato)

For over ten years, **Lynette Cook** has focused on depicting extrasolar planets along with images related to the Search for Extraterrestrial Intelligence (SETI) and life in space. Her art has been published internationally in a wide variety of periodicals, books, and television documentaries.

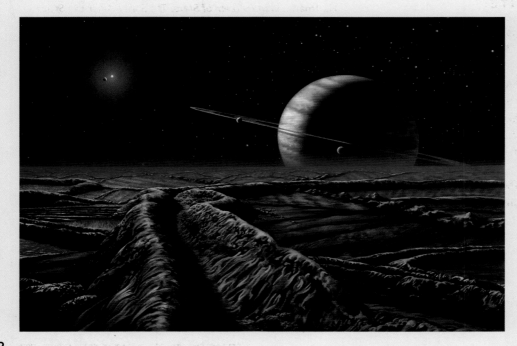

HD38529 SYSTEM BY LYNETTE COOK

HD38529, a star located 137 light-years away in the constellation Orion, is orbited by two planets. The inner world whips around its star in 14.3 days while the outer companion, shown here as a large ringed planet with three satellites, follows a 2,207-day orbit. The moon close up has icy sheets and ridges similar to those found on Jupiter's moon Europa. (Courtesy of the artist)

RESOURCES FOR ARTISTS IN THE AGE OF SPACE EXPLORATION

We live in an exciting time. Less than half a century ago, many planets were known only through fuzzy telescopic views. Today, spacecraft have visited every major planet except Pluto, and the *New Horizons* mission is on its way there for a flyby in 2015. Astronauts have ventured only as far as the Moon, but through robot eyes we have roved the distant sands of Mars and watched Venus from balloons high in its atmosphere, while landers have explored its surface. We have seen close-up views of the moons of Mars, Jupiter, Saturn, Uranus, and Neptune, as well as comets and asteroids, a few of which our robot craft have even landed on. Advanced projects, including blimps in the orange fog of Saturn's moon Titan and submarines on Jupiter's moon Europa, are under way to explore, firsthand, places we've seen only at a distance. Like the missions before them, these explorers promise to deliver a wealth of resources that will enable artists to depict these distant worlds in new and creative ways.

The International Association of Astronomical Artists (www.IAAA.org) is an organization of space artists worldwide. Their website has paintings and resources for the up-and-coming space artist, and many links to artists' websites. If you don't have Internet access, IAAA can be reached at:

P.O. Box 3939
Carmel-by-the-Sea, CA 93921
Or
99 Southam Road
Hall Green, Birmingham
B28 0AB England
United Kingdom

WEBSITES

Today, the Internet is a powerful resource for space artists. For photos of the planets and moons, try NASA's Planetary Photojournal. Other images are available under the websites of specific missions.

NASA's Planetary Photojournal: http://photojournal.jpl.nasa.gov

Hubble Space Telescope: http://hubblesite.org

Clementine (the Moon): http://www.cmf.nrl.navy.mil/clementine/

Lunar Prospector (the Moon): http://lunar.arc.nasa.gov

Magellan (Venus): http://www2.jpl.nasa.gov/magellan

Spirit and *Opportunity* (Mars):
 http://marsrovers.jpl.nasa.gov/home/index.html

Galileo (Jupiter): http://www2.jpl.nasa.gov/galileo

Deep Impact (comets): http://deepimpact.jpl.nasa.gov

Stardust (comets): http://stardust.jpl.nasa.gov

Near Earth Asteroid Rendezvous (asteroids):
 http://near.jhuapl.edu

Japan's *Hayabusa* (asteroids):
 http://www.isas.ac.jp/e/enterp/missions/hayabusa

Cassini (Saturn): http://saturn.jpl.nasa.gov

My own website (www.spacedinoart.com) also has links to various resources. Come visit me!

BOOKS

There are excellent books at libraries and bookstores with a plethora of rich color images you can use as resources for your paintings. Here are just a few:

Bell, Jim. *Postcards from Mars: The First Photographer on the Red Planet.* New York: Dutton, 2006.

Carroll, Michael, and Rosaly Lopes. *Alien Volcanoes.* Baltimore: Johns Hopkins University Press, 2007.

Fischer, Daniel. *Mission Jupiter: The Spectacular Journey of the Galileo Spacecraft.* New York: Springer, 2001.

Hardy, David A. *Visions of Space.* London, UK: Paper Tiger, 1990.

Hardy, David A., and Patrick Moore. *Futures: 50 Years in Space.* New York: Collins Design, 2004.

Hartmann, William K., and Ron Miller. *The Grand Tour: A Traveler's Guide to the Solar System.* New York: Workman, 2005.

Lovett, Laura, Joan Horvath, Jeff Cuzzi, and Kim Stanley Robinson. *Saturn: A New View.* New York: Abrams, 2006.

Miller, Ron, Frederick C. Durant III, and Melvin H. Schuetz. *The Art of Chesley Bonestell.* London, UK: Paper Tiger, 2001.

Sokolov, Andrei, Ron Miller, Vitaly Myagkov, and William K. Hartmann. *In the Stream of Stars: The Soviet-American Space Art Book.* New York: Workman, 1990.

MAGAZINES

There are a number of magazines that provide news and views, as well as photos.

Astronomy: http://www.astronomy.com

Discover: http://www.discover.com

National Geographic: http://www.nationalgeographic.com

Sky & Telescope: http://skytonight.com

Astronomy Now (UK): http://www.astronomynow.com

The resources available to us today, and the plans to explore more of the cosmos around us, make it a perfect time to delve into the wonders of space art. Through our paintbrushes, we can explore worlds that humans may never see and others where our children's children may live. Our visions of the planets and moons around us can inspire and educate. So, pick up a paintbrush, grab a canvas, and travel to your own cosmic getaway!

INDEX

A

Acrylics, 28
Alien sky, 34–35
Asteroids, 21, 128–133
Atmospheric perspective, 17, 51

B

Bonestell, Chesley, 9–10
Brushes, 29–30

C

Canvas, 29
Canvas board, 29
Charon, 110–119
Color, 30–32
 in space art, 90
Colored pencils, 20
Color theory, 31–32
Craters, 21–22
 planets without, 23–25

D

Deimos, Mars from, 56–61
Drawing technique, 14

E

Earth from the Moon, 38–43
Earth-like worlds, 36–75
Earth sky, 33–34
Erasers, 14

F

Field sketches, 27
Fisheye perspective, 80

G

Galilei, Galileo, 9
Gas giants, 23–25, 76–107
Gesso, 29
Graphite pencils, 14
Great Red Spot, 24–25, 84

H

Hard-surfaced planets, 26
Horizon, 44

I

Iapetus, 91
 Saturn from, 91–99

Ice worlds, 107
Illustration board, 29
Io, 78
 Jupiter from, 78–83

J

Jupiter, 9, 78
 clouds on, 84–89
 from Io, 78–83

K

Kuiper Belt, 110

L

Light year, 120
Limb darkening, 26

M

Mars, 9
 ancient, 62–67
 from Deimos, 56–61
 images of, 10
 modern, 70–74
Mars rovers, 72
Martians, 10
Mercury, landscape on, 44–47
Mesas, 19–20
Moon, 9, 38–43, 75
 Earth from the, 38–43
 phases of the, 16
Mountains, 16–18

N

Nature, randomness of, 18, 22
Nebulae, 128, 135
Neptune, 100
 from Triton, 100–106
 worlds beyond, 108–142

P

Painting surfaces, 29
Paints, 28
Paper, 14
Pencils
 colored, 20
 graphite, 14
Perspective
 atmospheric, 17, 51
 fisheye, 80

Phobos, 56, 59
Plein air challenge, 68
Pluto, 110–119
Proxima Centauri, 120

R

Randomness of nature, 18, 22
Resources for artists, 143
Rocks, painting, 52
Rudaux, Lucien, 9

S

Saturn
 from Iapetus, 91–99
 rings of, 92–95
Science fiction writers, 10
Shadows, 15, 122
Size of planets, 79
Sky
 alien, 34–35
 Earth, 33–34
Soft-surfaced planets, 26
Space art, 9
 color in, 90
Spheres, drawing, 15
Sponges, using, 41, 42

T

Talus slope, 19
Telescopes, 9
Triton, 100
 Neptune from, 100–106

V

Venus, 10
 volcano on, 48–54
Volcano on Venus, 48–54

W

Water world, 135–141
Websites, 143
Worlds
 beyond Neptune, 108–142
 Earth-like, 36–75
 ice, 107
 with two suns, 120–127
 water, 135–141